STORYTELLING *for* PHOTOJOURNALISTS

Reportage and Documentary Photography Techniques

Enzo Dal Verme

Acclaimed international photographer

AMHERST MEDIA, INC. ■ BUFFALO, NY

About the Author

Enzo Dal Verme is an Italian photographer with over 15 years of experience in portraiture, fashion, and photojournalism. He has traveled the globe extensively in search of stimulating stories and interesting people to photograph and interview.

His work has been published in *Vanity Fair, l'Uomo Vogue, The Times, Marie Claire, l'Espresso, Madame Figarò, Elle, Glamour,* and many other magazines.

This book started as a self-published PDF book targeted to photography students seeking advice. The book turned out to be a success, mainly among professional photographers—hence the expanded and enriched print edition.

Enzo also teaches intense, exiting, fun, and sometimes challenging experiential workshops designed to help participants enhance their ability to interact with their subjects and compose their images quickly and intuitively.

His pictures have been shown in major art galleries and festivals.

One more thing: he loves tofu!

Special thanks to Robert Burns, language professional.

Published by:
Amherst Media, Inc.
PO BOX 538
Buffalo, NY 14213
www.AmherstMedia.com

Publisher: Craig Alesse
Senior Editor/Production Manager: Michelle Perkins
Editors: Barbara A. Lynch-Johnt, Beth Alesse
Acquisitions Editor: Harvey Goldstein
Associate Publisher: Kate Neaverth
Editorial Assistance from: Carey A. Miller, Sally Jarzab, John S. Loder
Business Manager: Adam Richards
Warehouse and Fulfillment Manager: Roger Singo

ISBN-13: 978-1-68203-000-4
Library of Congress Control Number: 2015953684
Printed in the United States of America
10 9 8 7 6 5 4 3 2 1

www.facebook.com/AmherstMediaInc
www.youtube.com/c/AmherstMedia
www.twitter.com/AmherstMedia

Contents

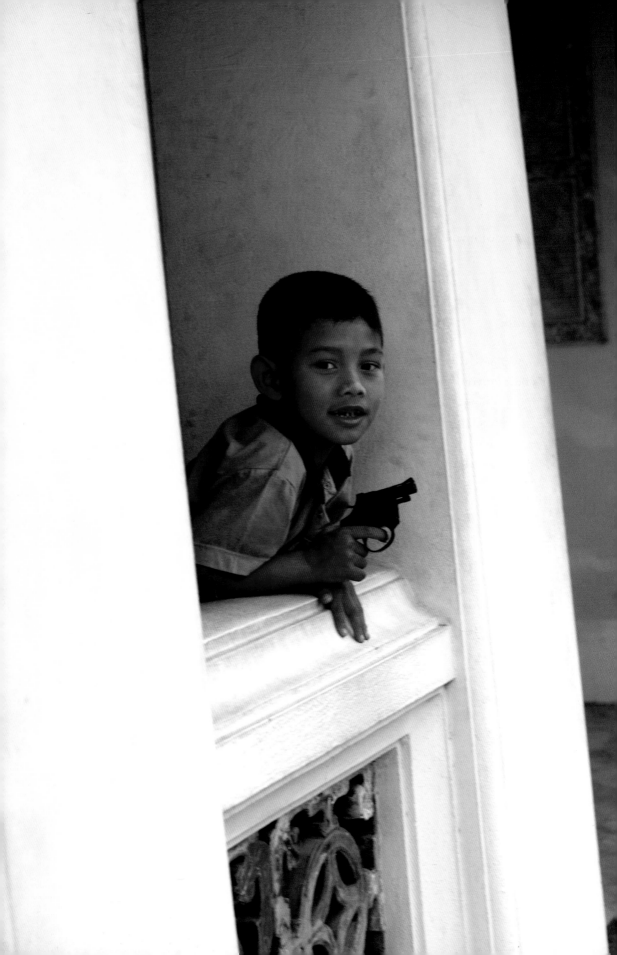

1. How to Shoot Reportage

As I keep receiving requests for tips on how to shoot reportage, I decided to write this book. I will share with you what I have learned from my mistakes and experiences around the world so that you might be ready for . . . different kinds of mistakes! Be aware that the information in this book is what works for me; it is not the only way to do it. You will have to discover on your own what's best for you. My clients usually ask me for interesting or even light stories. But "light" doesn't necessarily mean "easy to do." Keep in mind that I am not a war reporter, I don't do extreme investigations, so I will not explain how to do that kind of shooting.

In the following pages, you will find plenty of practical tips that will help you organize and shoot reportage. Between the moment you spot a powerful subject and the moment you bring your work to the editor's office, you need to take into consideration an awful lot of things. Most of them will become automatic once you have become familiar with them.

So, what's important in order to shoot a good reportage? First of all, everything starts with a good idea.

◄ **Kid with a gun in Bangkok.** ▼ **Construction worker in Shanghai.**

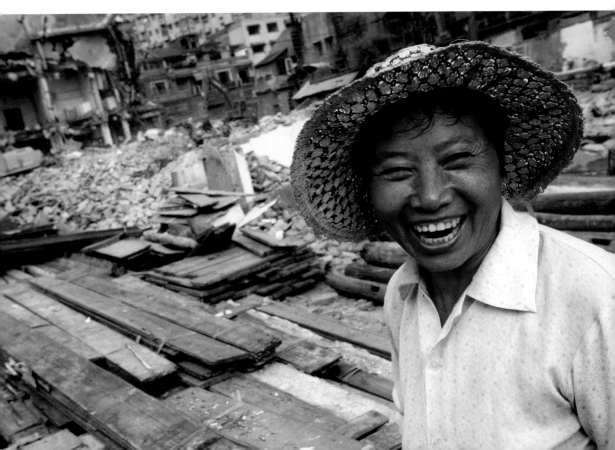

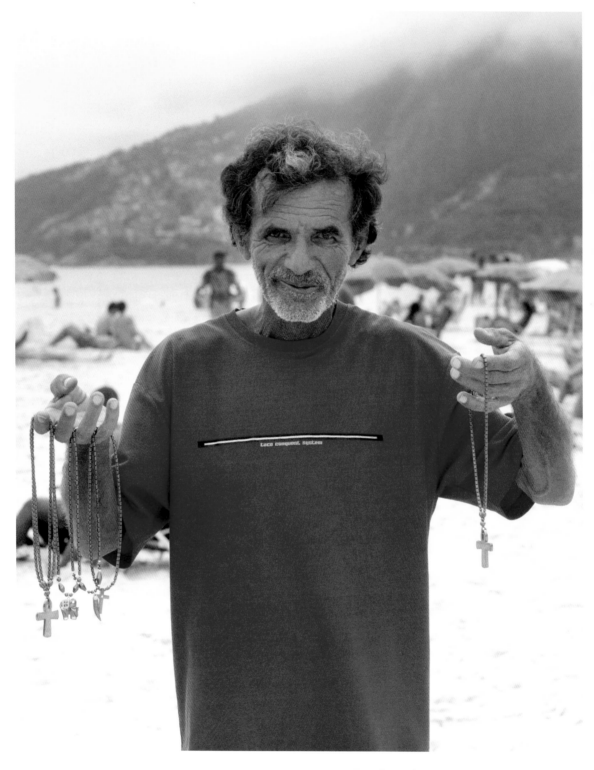

▲ Beach vendor, Posto 9, Rio de Janeiro.

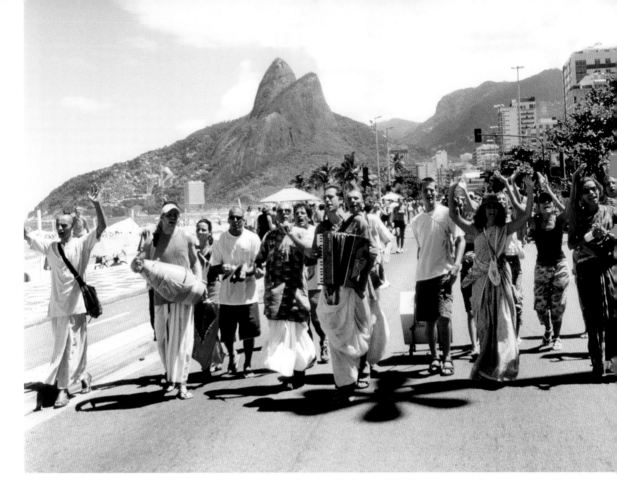

You don't need to know exactly what you are going to find out (otherwise, where is the fun?), but you need to have an inspiration and enough passion to start your inquiry. Are you aware of something going on that could be a good topic for an article? What kind of magazine might be interested in publishing it? If you have an established business relationship with a magazine, go talk about your idea with the editor. The feedback will help you to find out the best angle. If this is a new experience, you will need to shoot the reportage first and then try to sell it. In both scenarios, your idea needs to be strong and interesting, your mind empty and curious.

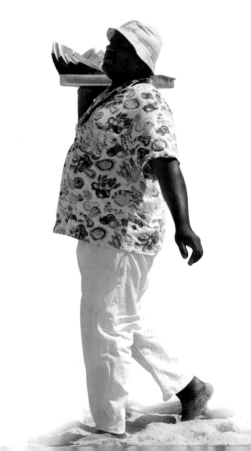

▲ Hare Krishna in Rio de Janeiro.
▶ Beach vendor, Posto 9, Rio de Janeiro.

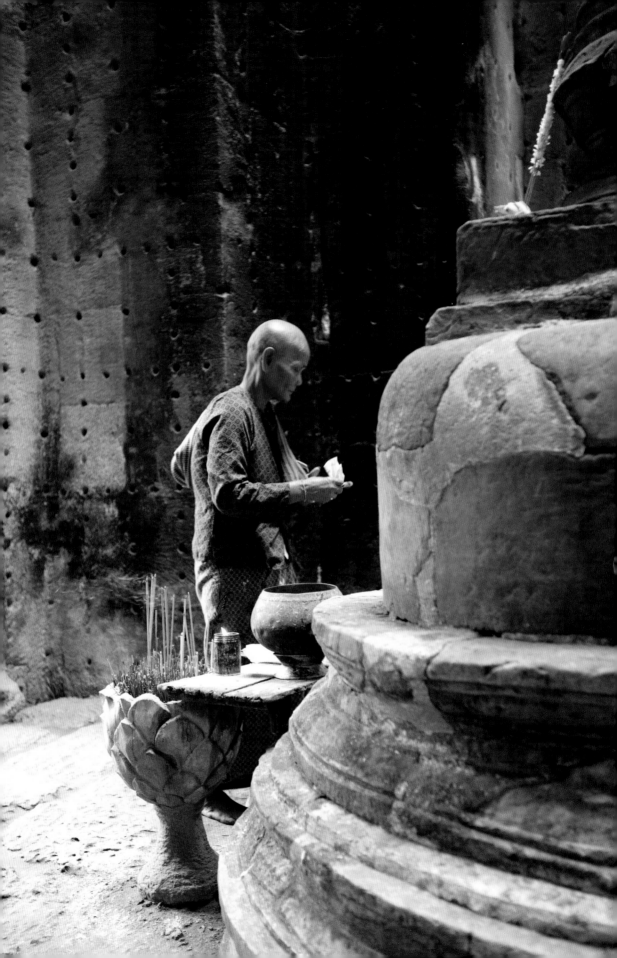

2. How to Find Inspiration

I have been asked: "Where and how do you get inspired?" This is really something you can't plan. It may be that a friend wants to chat about a particular experience or that I meet a person who shares some information with me or that I go on a trip and become curious about a certain topic. Other times, I overhear a few words in a conversation between strangers, read some headline as I pass by a newsstand, or discover something while surfing the Net. Even the writing on a wall can stimulate my imagination.

If I get excited about exploring the matter, I try to find out more about it and what kind of potential it might have as a story.

It can happen that I spot a great topic but realize that producing it properly would require too many resources (e.g., money, time). For instance, a story about a certain tribe might require several months of living in the jungle with them. In that case, I'd write the idea on my wish list for future re-evaluation. My best stories have been on topics that I bumped into without thinking too much and that met the favor of a magazine when I talked to them about it. My suggestion is: stick to something that you are really interested in exploring for one reason or another and keep your feelers up all the time.

◄ Cambodian nun. ▼ Camburi beach, Brazil.

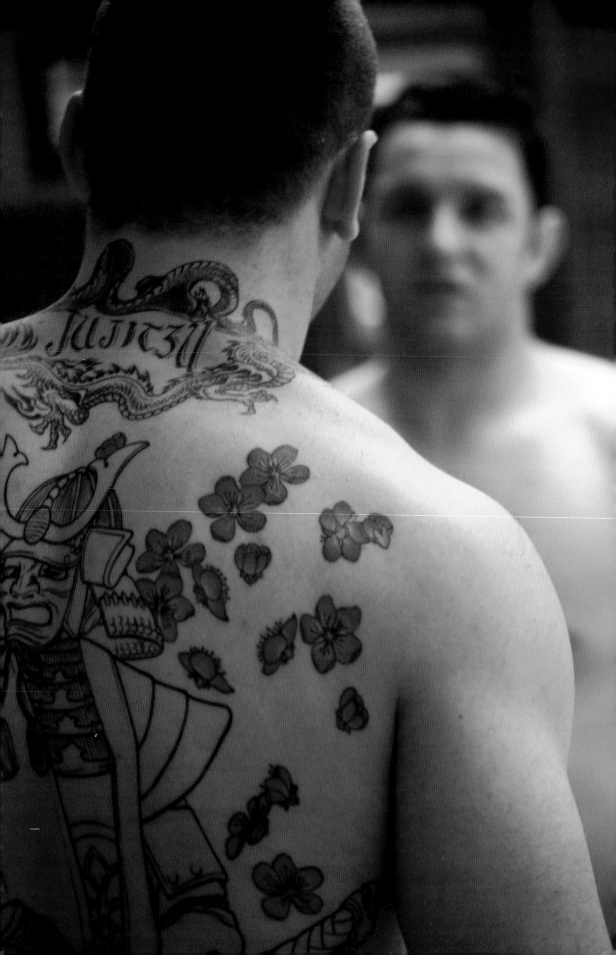

3. Why Do You Want to Shoot Reportage?

Before you start the adventure, ask yourself why you want to do it. If you are a beginner, you may well be about to invest money that you'll never see come back. If you are, let's say, an industrial photographer who is eager to expand your professional horizons, hold on to your clients. In a market in which magazines are paying less and less (did I say *less?*), shooting reportage is becoming a luxury. On the other hand, if you feel the urge to share what you and only you can see about a certain topic, buckle up and go for it!

My point here is that a professional photographer makes his living from the images he shoots. To me it makes sense to tackle a topic if I know the images will sell and be shared with lots of viewers. The reward is not merely monetary: it feels good knowing that thousands of readers might get inspired by my report on, let's say, a good cause.

Not everyone has my same drive. I know of amateurs who are happy to shoot reportage just for the creative pleasure of taking pictures. Whatever reason drives you, my suggestion is to be clear about it in your mind so that you can choose the approach that is most appropriate for that aim. It will make things a lot easier, and your work time will be more productive and relaxed.

◀ Jujitsu fighters. ▼ Drag queens in São Paulo.

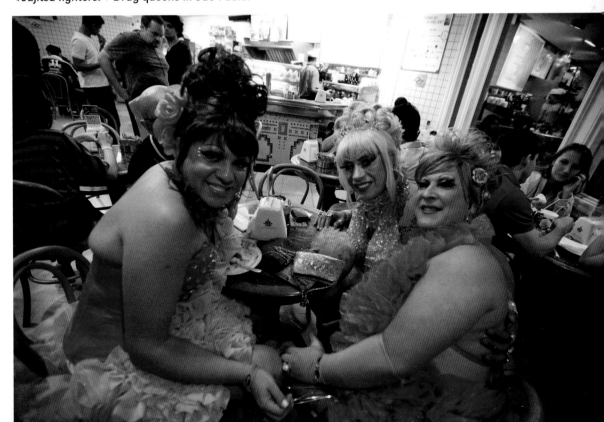

4. What Kind of Reportage?

You need to be realistic about the subject and the market. For instance, if you decide to shoot tourism reportage, ask yourself: can I find this in a tourist guide? If the answer is "yes" or even "maybe," you are probably wasting your time. Reportage is interesting when it gives you new information or a fresh look at a certain topic. That's why, in my opinion, the lens of a seasoned professional photographer is not necessarily always pointing at something more interesting than the one of an absolute beginner. Now, is the absolute beginner able to get good results despite the lack of experience? Sometimes, yes. The important thing is always to keep in mind which angle you are giving to your story.

If you are on assignment, your client might well expect the sort of shot we've all seen published a million times. Please your client, but keep your eyes open for something more interesting (that you may or may not include in the final reportage).

There are very many potential points of view for every subject, and all the images of your reportage need to be coherent. I often shoot a collection of portraits; other times, I opt for a snapshot style or maybe a more classic approach. Find what works for you and your clients.

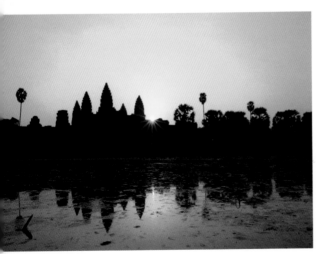 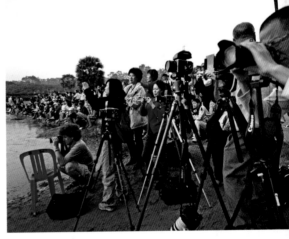

◄ Claude playing with a gun, Milan. ▲ This peaceful, romantic view of the sunrise at the Angkor Wat Temple (left) was published in the glossy magazine that commissioned me to do the reportage. That morning, at the Angkor Wat Temple, I wasn't alone. The pictures of the swarming horde of amateur photographers spreading everywhere around me (right) was not what my client was looking for.

5. Uplifting Photojournalism

Imagine holding a big, fresh, juicy lemon in your hands. Now imagine cutting it into slices. Feel the acidic juice dripping onto your skin and perceive the overwhelmingly sour aroma spreading in the air. Now, take a juicy slice and stick it in your mouth, suck on it, and taste its pungent tart flavor.

Is your mouth salivating? More than likely yes, because our body responds to images.

Athletes, surgeons, musicians, actors, and stockbrokers use visualization to improve their performance. Visualization is used to quit smoking and control weight; it is even used by cancer patients. It's not magic, but it is a powerful tool: what we see can affect our psychological and physical states. Now, some people deliberately visualize an ideal future in order to be halfway there, but most people constantly visualize bad news about the economy, planet, society, etc.

Is this affecting our future? I believe so. Some people say that the tragic state of our economy is a self-fulfilling prophecy. I wouldn't go that far, but I am pretty sure that the quality of news and information that we are constantly exposed to has an impact on the course of our civilization.

Having some experience in the information industry, I see this as an ethical issue. I have a great deal of admiration for all those photographers who put their lives on the line to report on tragic issues. It's absolutely right and proper to call attention to the terrible injustices around us. At the same time, I believe that storytelling could be used a bit more to inspire viewers and a bit less to show the atrocity and horror of our world.

Recently, I saw a photo essay showing nothing but the sadness and squalor in the lives of two prostitutes. The composition,

◀ Salivating? There's proof that our bodies respond to images.

lighting, colors, and everything else were perfectly devised to underscore just how miserable these two human beings were. I found that irritating. There is enough sadness in our world, and there is no need to exaggerate it or keep re-creating it.

There is a difference between constructive information/denunciation and the tendency to linger complacently on unhappiness or bad news or the tendency to transform the ugliness of our world into an entertaining product.

But honestly: is this a surprise? We are very used to bad news; information organizations often select what to cover by its degree of truculence: one person killed may have a hard time making the news, two or three have a better chance, a massacre is likely to have a great audience, and a huge disaster will keep the viewers glued to the TV screen and to the pages of newspapers and magazines for weeks.

But how about showing the beauty of our world from time to time? No, I am *not* suggesting that we look at the world through rose-colored lenses and become oblivious to a troubled reality. I am only offering my point of view on the need for uplifting, encouraging, inspiring news.

Now, imagine if all media suddenly changed the current trend and started dedicating equal time to bad news and good news. How would that be? Okay, let's be really Utopian: imagine if the media began bombarding us with news that focuses on solutions rather than problems, articles on empowering innovations. Here is an example of what I mean by inspiring news:

In Malmo, Sweden, a project sponsored by the government inaugurated a system that turns domestic waste into methane gas and fertilizer. Stockholm Water now produces several billion cubic meters of methane gas, which is used for private cars, public transportation, and one train. Municipal street cleaners now have a lighter job, and taxes on wastes have been reduced.

This is a big thing. Did you ever hear of it? Highlighting success stories can be positively contagious—someone might want to replicate that idea—but how much space is the media actually dedicating to this kind of good news? Here's another example: a Brazilian student has invented a shoe device that recharges mobile phones while you walk. See what I mean? The world is not made only of problems, but the information industry really directs a lot of attention to violence, wars, disasters, and scandals—the rougher the better. Two politicians fighting on TV ensures a higher audience share than a composed and intelligent discussion.

Unfortunately, the most commonly offered alternative seems to be evasion: brainwashing reports on celebrities; stories on what's cool, fashionable or funny; and other sensational or escapist infotainment.

For me, publishing mainly in fashion magazines, it's always sad to realize that my clients have a weakness for a frivolous angle and would like me to glamorize every report that I shoot.

Honestly, I am driven by a slightly subversive instinct. In recent years, I have been able to give space to issues that do not necessarily match the latest lipstick color.

One example is the successful series *Urban Local Heroes* (shot for the Italian magazine *Flair*), where I looked around the world for everyday people working on innovative projects in their communities. It feels good knowing that my stories can help readers find out that getting involved in a community project may be much more fulfilling than buying the latest shoes. Unfortunately, this is not always possible because magazines are very careful to publish only what sells and doesn't clash with the interests of advertisers. Still, I love the fact that the aesthetic of the tragic or the glamorization of reality are not the only two alternatives in our information panorama. The portion of the public that shows their appreciation for empowering reports seems to be growing, and this is good news.

Information can affect our psychological state, the way we perceive reality, and the decisions we make. An increase in uplifting, encouraging, and inspiring news could possibly affect our lives and our future. Can you picture it? That's why I go for uplifting photojournalism. What about you? Would you like to work on uplifting features? You'll be amazed about the number of good news angles to cover you will find, once you start looking for them.

Monique Fagan. When her beloved brother died, Monique decided to leave Africa and moved to Holland, but she wasn't comfortable there. She said, "I felt like Tarzan visiting the civilized world for the first time: people were throwing things away that would have been much needed in Africa. My first impulse was to create a company to export Dutch garbage to Africa, but that was too complicated."

On top of the death of her dear brother, her interaction with Europe made her lose her faith in God and in progress. She moved back to Africa very sad and started walking on the beach every day asking the sea and mountains what the meaning of all that was. One day the sea answered her by throwing a lot of garbage up onto the beach. That was a sign. Monique created her first sculptures made out of waste remembering that, while in Holland they certainly do throw away many things, they also recycle a lot. She was happy about the new direction . . . but one day she went to the beach to collect garbage and found that a group of environmentalists had cleaned everything away! At first she was disoriented, almost angry at those people, but after discussing it with them they worked out a way to cooperate. Now several families make a living thanks to Monique's idea, creating sculptures and lamps that are sold in shops. When I photographed and interviewed her, she was planning to export to Holland. In her house, I read something she had written on one of the walls in pencil: "Pain is unavoidable, misery is optional."

Kristian Mokelby. I captured this portrait of Kristian many years ago. He insisted on going up on the hills around Oslo to be photographed with the town in the background. I shot the image that he wanted, but I wasn't convinced. So I jumped on the back of a parked pickup truck and got a quick shot of him standing in the road. That is the photograph that ultimately was published.

▲ (left) Monique Fagan, sculptor, Cape Town. ▲ (center) Kristian Mokleby, entrepreneur, Oslo.
▲ (right) Nana Yuriko, multimedia artist, Berlin. Images from the series *Urban Local Heroes*.

As a young man, Kristian dropped out of school in order to devote himself to photography and skiing. He worked as a carpenter to pay his bills, and then he invented his first enterprise: a healthy fruit juice blend. Why? "I was fed up with sodas with dubious ingredients. I wanted to drink a good natural fruit juice. Since I couldn't find it on the market, I created it," he said.

Was it successful, I asked? "Very much. Many other people had the same need and I felt encouraged to start the following project: A café, take away, and catering of healthy food. My partners are a dietitian, a cook, and a baker. Our prices are ridiculously low. Yes, it is possible."

Nana Yuriko. When I photographed Nana, she was busy with her performances that "couple art with service." Dressed as an eccentric hostess, she parked the camper of the Berlin Tourist Information International, the organization she founded in 2002, in crowded places in and around Berlin. With the help of two other hostesses/artists, she distributed flyers that provided information about the city's arts scene: galleries, music labels, concerts, publishing houses, artists, and shows.

"Berlin swarms with interesting cultural initiatives that nobody even suspects exist," she explained. She supported herself by selling limited-edition art souvenirs. Nana stressed the importance of "giving the possibility to the people to ask stupid questions about art and culture: art mustn't be snobbish!"

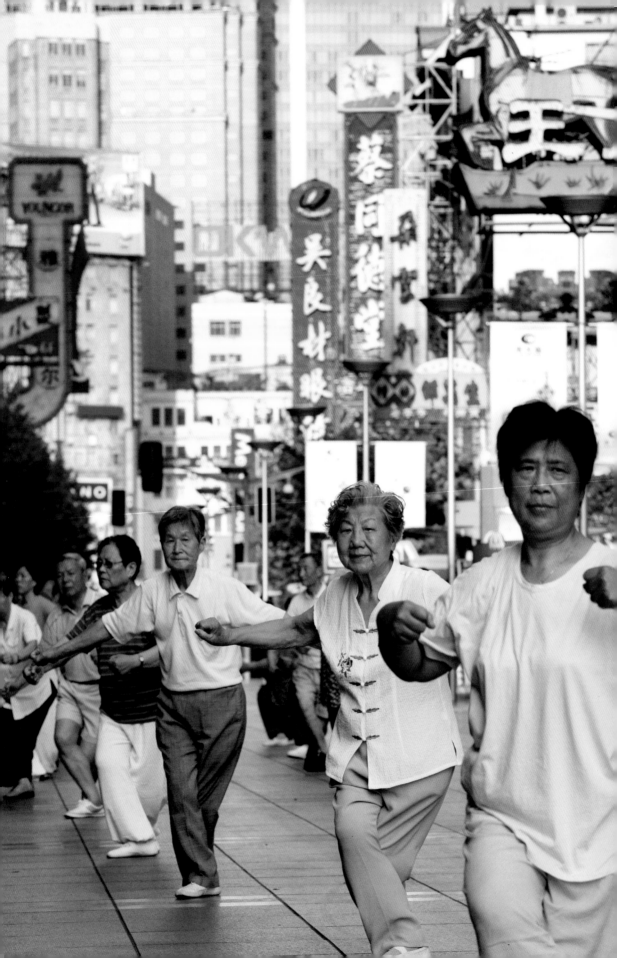

6. Be Ready to Be Flexible

Once I was getting ready to shoot a story in Bombay. I had already shot similar stories in several big cities around the globe and—as usual—all of my preproduction work was focused on finding those special individuals who have an innovative vision and a good influence on their community. I had already found a number of passionate and enthusiastic people responsible for incredibly creative and effective projects. One of them created an ingenious network to recycle trash, another one founded an organization that offered surgical services to poor people at no cost, and another one was defending the mangrove forests from destruction.

Two days before flying to India, the editor told me that she changed her mind. She'd rather have a story on the wealthy people and their crazy parties. Despite the sudden change in topic, I wasn't totally unprepared. Of course, I had to reorganize, contact more people, and research different information, but everything went pretty smooth. I was actually able to shoot both stories and managed to sell the original one to a different magazine when I got back from my trip. When you are used to last-minute changes and unforeseen events, problems can turn into opportunities. Well . . . within certain limits.

◀ Tai chi in Shanghai. ▼ Fields around Siem Rep.

7. Getting Ready

You have decided that you are shooting, let's say, a reportage on an eco-village in Iceland because you know that you will find something really interesting and you already have in mind where it could be published (or you managed to get an assignment from one of the magazines you work for).

Now you need to make the first contacts. Here, the Internet can offer great support. Post a few announcements on your favorite social media sites and others where you can be seen (see next chapter). The answers might surprise you. Locals will let you know if the place you want to visit is worth your interest or not. Someone may give you a tip on a less-known spot. Others will try to get your attention in order to be mentioned in your article. Everything could be useful. What has already been published on the subject? Is there any expert whom you should meet? What are the controversial aspects of the topic you are about to cover? Are the locations on your list visually appealing? How is the weather? Do you need special permits to photograph certain places? How will you move around? You can research data and information from numerous Internet sites, from Wikipedia to Reliefweb, from the United Nations to the CIA factbook, and anything in between. NGO sites are often rich in news that you are unlikely to find on conservative media.

Blogs might also be useful but, depending on their owner, you might want to double check their content.

You also need to set up a budget. If you are a freelancer, you know how much money you will or might be paid for your work. I always tend to produce more than one reportage for every trip in order to better amortize the investment.

Once you have a general view of what seems to be possible and how much time you need, look for accommodation and the best airfare (with changeable dates). If you need a visa, make sure to get one that lasts a bit longer than your plane ticket. If you are going to a country where this is not possible (like Russia), make sure you have everything you need to extend your visa in case you need to stay longer.

Set up an appointment for your very first day, choosing the most enthusiastic among your local contacts, then try to set up more meetings, at least for the following day. Local contacts are often the fastest way to get a reality check on what you are about to explore. They can also tell you where to find stories to enrich your feature. Imagine the portrait of the third-generation owner of a pastry shop: "My grandmother met my grandfather buying a fruit pie, like this one, which is still prepared using my great-grandmother's recipe . . . " See what I mean?

8. Online Networking and Surfing for Contacts

Considering the kind of reportages that I shoot, I found it very useful to look for preproduction contacts on Asmallworld.net. I usually find what I am looking for. Some photographers are more into the Facebook thing. Occasionally I get some help, but it doesn't seem to work well for me. Things are almost the same with Google+; often, there is a cooperative attitude, but it all depends on whom one is connected with. On Facebook, I have two accounts: a personal one for friends and various people I know not only virtually and another one that was linked to my blog (now offline) where I am connected—like on Google+—with photography enthusiasts whom I don't necessarily know. I've gotten a little help using Twitter and, so far, I have found some good contacts on Linkedin, especially through other group members. The secret lies in carefully phrasing the request that I want to post in the group. Lightstalkers.org is a very good resource for finding fixers (locals who are hired to help) or tips from fellow photographers. Another very good place to ask colleagues for advice is Photoshelter.com; its forums are attended by professionals and amateurs who are usually very eager to give support to people who are asking for tips or looking for contacts.

A couple of times I posted a classified ad on Craigslist.org and got a lot of responses. Most of them were not so useful, but some were good. Quora.com does not allow you to post any kind of request (for instance, "I am looking for contacts"), but it's an excellent place to research information on the topic of the reportage.

▼ Surfers in Camburi, Brazil.

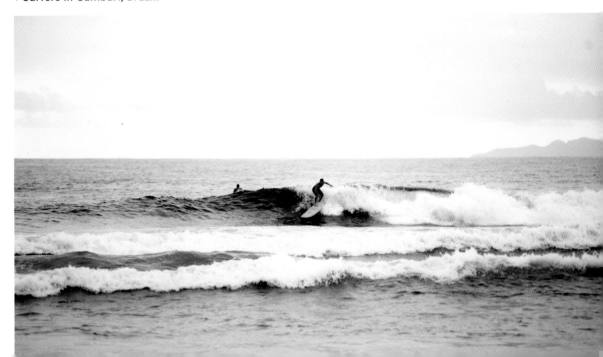

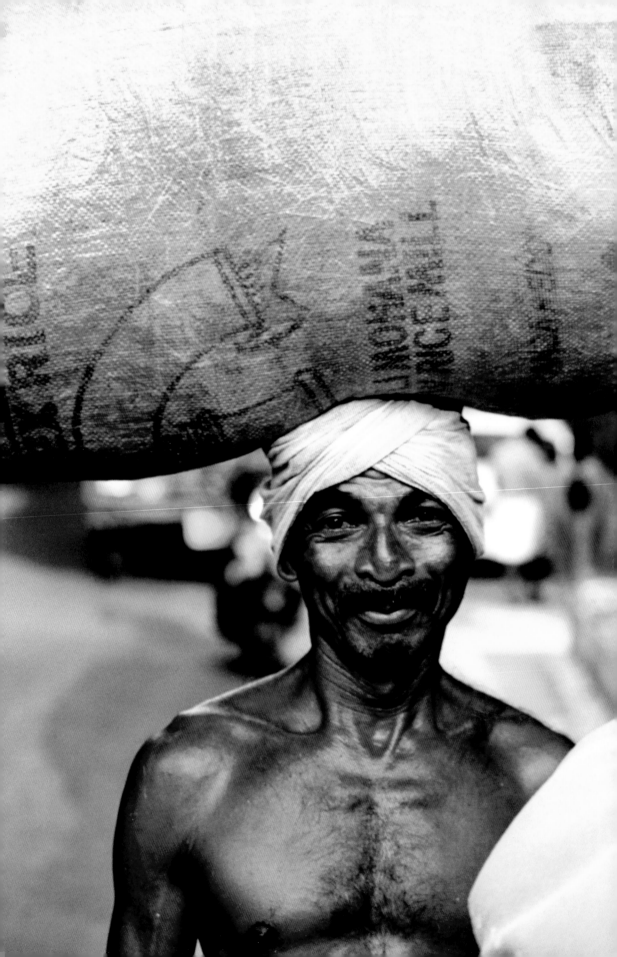

9. Your Luggage

First rule: travel light. If something is not essential, don't bring it with you. On the other hand, make sure that you have everything you really need and that you don't have to waste precious working time because you have to do the laundry.

It's also a good idea to bring clothes that suit the environment you are visiting. Once I found myself entering a party in Shanghai wearing my camouflage shorts while almost everyone was sporting expensive evening wear. "It's an informal soirée," I was told. But I didn't consider what they really meant by the word "informal." Being a Western photographer, I had no problem getting in; other times, it has been a bit more complicated. For instance, on one evening, I was kept from entering a club in New York with someone waiting to be photographed by me inside. Luckily, a PR person who knew me arrived a few minutes later and explained to the doorman that I had to shoot a picture for *Vanity Fair*. My camouflage shorts are really comfortable, but now I always try to bring something more formal too.

Another important precaution that I take concerns all the addresses and phone numbers I need, both on location and back home. On top of having them in my computer and in my cell phone memory, I carry them printed on paper. In Bali I fell into a swimming pool while I was shooting an interior design reportage. I managed to save my camera by holding my hands up, but the cell phone in my pocket died. In China, my laptop dropped from my backpack to the marble floor of a big hotel. In Berlin, my laptop screen simply stopped working and I had to replace it. A sheet of paper is not so heavy to carry.

On top of my toothbrush and dental floss, I always carry with me:

- plane tickets
- passport
- insurance documents and contact numbers
- credit cards and cash
- business cards (plenty and suitable for different occasions)
- model releases
- phone numbers (local embassy, local contacts, the magazine you are working for back home, stolen credit cards emergency number) printed on paper
- ear plugs (they are useful when you need to sleep on the plane or in a noisy hotel)
- plug adapter (if you are visiting a country with different electric plugs. Here is a list: http://electricaloutlet.org)
- aspirin (you can't buy it everywhere)
- umeboshi pills (made of Japanese salted plums; aid for stomach problems)
- echinacea drops (a great natural remedy if you feel the flu is on the way)

◀ **Man carrying a sack in Kovalam, India.**

- high-protection sunscreen (if I am visiting a country with a strong sun and I need to shoot outdoors)
- mosquito repellent (if needed)
- protein bars (I often have no time to eat a meal, and I need energy to keep going)
- clothes, the bare minimum so I can always be proper without wasting time at the laundry. (My outfits for a week in the jungle are different from the ones that I carry for a week of high-society parties. If I have to spend long hours in the sun, I might need a hat. In the desert, a light scarf is helpful.)
- two pairs of shoes: one on me, the other one in the bag (you never know!)
- an extra change of clothes in your carry-on (in case your suitcase is lost)
- a pen (you'll always have one when you need one!)
- prescriptions and other valuables to keep with you at all times

Professional photographer associations often post on their sites samples of business forms such as cost estimates or model releases. Before leaving, you might want to visit their site and download templates of useful forms.

I never bring a guide with me, but I know of photographers who always carry a *Lonely Planet*. If you are visiting malaria-infested areas, places with extreme weather conditions, or countries with violence or other public order problems, you will have to take all the necessary precautions. As I said, I am not a war reporter and I won't list bulletproof vests and such. When visiting dangerous areas, ensure that someone knows where you are or travels with you. Also, carry blood-type identification on you.

When I fly, I carry my camera, lenses, and computer with me on board. If you have a lot of equipment, you can store it in a foam-lined case and entrust it to the fragile material gate. But, beside the fact that you never know how it will be handled, it might happen (and it does happen!) that your luggage is delayed and you have to wait for it one, two, or more days.

Be mindful about the dimensions of your carry-ons. Restrictions regarding size and weight may vary from airline to airline and flight to flight. If you're in doubt, give the airline a call before you fly. If you need to put some of your equipment in your checked bag, be sure to lock it. It has happened that, upon arrival, travelers get their luggage in perfect condition but with some of the contents missing. Anyway, you don't want to travel with a lot of equipment.

◄ **Rice field in Bali.**
► **Cambodian monk.**

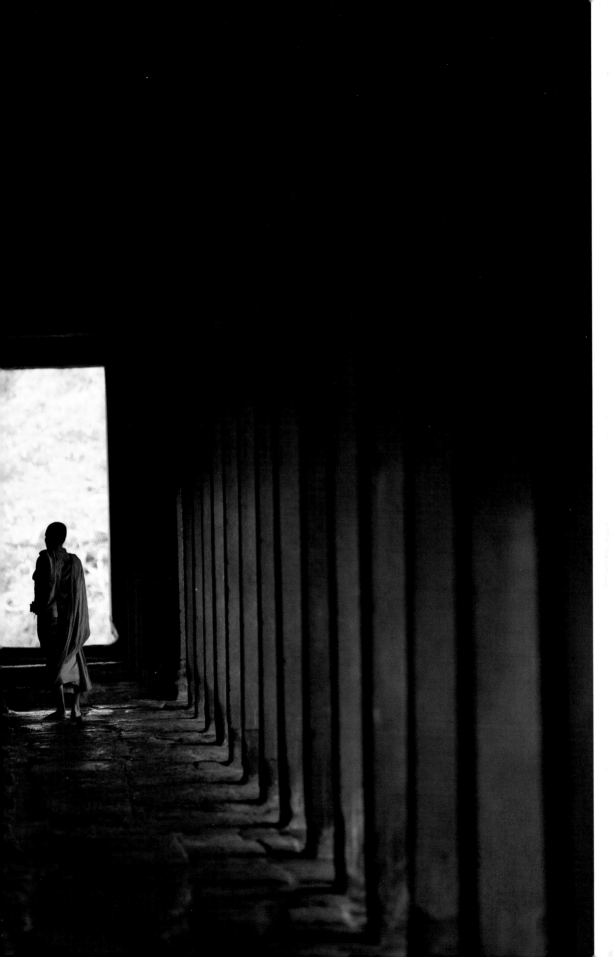

10. Technical Stuff

I know photographers who are always shooting with two 35mm cameras with different lenses hanging around their neck plus a Leica and maybe a compact camera too. Others keep their camera on a tripod. Personally, I bring one camera body with an EF 50mm f/1.4 for portraiture, an EF 16–35mm f/2.8L II (in my opinion, it is the most useful lens for reportage), an EF 70–200mm f/2.8L IS to take shots at a certain distance from the subjects, and an EF 100mm f/2.8 macro. The 85mm f/1.2 is particularly great for portraits. In any case, opt for lenses that are f/2.8 or faster. The less light you need to shoot your pictures, the happier you will be in low-light situations.

Take plenty of batteries with you and maybe a second battery charger (they break or get forgotten in hotels!)

A blower brush will be useful, especially when shooting outdoors where dust might get into your camera when you change lenses. It's annoying to retouch all of your pictures to get rid of the same dust dots. Better to stop from time to time and gently clean your mirror and sensor with a jet of air so you don't touch the surface. Don't forget the lens-cleaning paper too.

Bring more than one high capacity/high speed memory card with you. You might not have enough time to download what you just shot onto your computer before the next picture opportunity comes up.

A tripod is often useful but can be problematic to carry. I use a small one that's just enough to hold my camera on a surface for night photography and long exposure times. If you suspect you might need one, a monopod is a good idea too. I also bring a flash (which I rarely take out of my bag) in case the situation calls for it. Another tool that's good to have is a special bag that contains only two lenses. I can fix mine with straps around my chest; it allows me to move freely in chaotic situations where my backpack (a black Lowepro) would be too bulky.

◄ Blower brush and lens-cleaning paper.
◄ Pocket tripod.
► Street vendor in São Paulo.

11. Arriving

The very first thing that I do once I arrive at my destination is to get a local phone number for my second cell phone: people are not happy to call you if they have to spend a lot of money. Usually I don't have to waste my time looking for a good deal because I already know which company is best for me, that's part of my preproduction planning. Shooting abroad means that every day has a cost and, with the little money that magazines are paying now, it's a good idea to get everything done in the shortest period of time. You won't have much time to sleep or eat. If you do, that means that your break-even point will be higher. From the moment you land, every minute must be productive (that doesn't mean stressed!) and your schedule must be always full. The first day is good for orienting yourself and figuring out what you can do on your own and where you would do better with the support of a local. I seldom use assistants or drivers, but sometimes they are essential.

After a day of shooting (or even more than once a day), I download everything onto my laptop and start the editing right away. I organize my pictures in a "first choice" folder (which will go through a

▼ **Mavis Bulelwa Nduzulwane photographed in Kayelitsha, South Africa, with some of the 200 kids that she manages to feed with the products of her kitchen garden.**

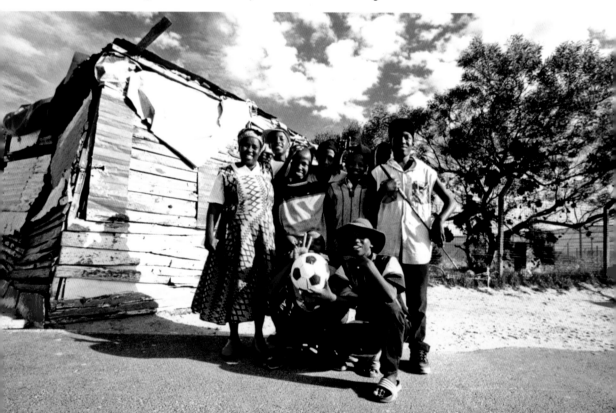

▲ **Dolomites.**

refined selection process further on) and a "reserve folder." By doing so, I have a rather quick overview of how the work is proceeding that allows me to decide what needs to be done. Be sure to write down names and information on what you shoot. You can do it directly in the captions of each image or in a separate document. Do it every day—it's so easy to forget names and other information!

If you are on assignment and you are not shooting for a magazine but for an agency, I suggest that you shoot in abundance. Most likely your agency will propose the reportage you are working on to different magazines in different countries, each of them with its own particular editorial line. It might have been helpful, during the preproduction phase, to have glanced through the publications potentially interested in your story and note whether they have more horizontals or verticals, show a preference for an intimate approach or go for a strong impact, if the pictures they publish tend to be shot with a wide angle or not, if they prefer "stolen pictures" over images where you see a contact between the photographer and the subject, and so on. Now it's time to take action. You might want to organize your pictures in several folders. But I warn you: it's not an easy task. To avoid confusion, stay focused on one angle.

Keep in mind that, most of the time, all the planning that has been carefully calculated will go in a different direction because of unforeseen events. Don't panic, and be ready to grab new opportunities to work on your story.

12. Practice Good Habits

Save Energy

Shooting reportage can be very tiring. I learned to save energy even in small things. For instance, when on a shooting trip I tend to take the escalators instead of walking up the stairs. That little energy saved might be very useful to fuel some extra effort later on.

Check on the Water

Check to see if the water is drinkable. Believe it or not, the London Heathrow airport has non-drinkable water. If you are back from a trip to a poor country and you want to get some fresh (finally clean!) water, think twice before having a sip of tap water. Always make sure it's drinkable—absolutely everywhere.

Tune In to Local Media

At home I never watch TV, but on a business trip one of the first things that I do is check out the local channels. Watching a soap opera, a reality show, or the news can give you an idea about that country, even if you do not understand one word.

Get Out and Socialize

Locate places to socialize. If you have never been in a certain place, it is very possible that you will find yourself somewhere that doesn't look the same way it was in your imagination. It smells different, it sounds different, and people's manners are way different from what you were expecting. Spot a few places where you can get a handle on the local reality: a crossroads, a bar, a supermarket, etc., and talk to people, ask information, try to connect. The first things I try to find out are: how much is the average salary of a blue-collar worker? What do homes cost? How much is a bus ticket? Is there a lot of crime going on? Homeless people? Drugs? What are locals proud of and what are they unhappy about? You might be surprised by what you discover.

Protect Your Camera

If you are visiting a country or an area where walking around with an expensive camera is likely to attract the attention of thieves, get some black masking tape—or, even better, some funny stickers—and cover the brand name. You are less likely to get mugged if you carry a Leica covered with Chiquita stickers than if you carry the same camera in all its splendor.

Beliefs and Behaviors

Find out about local beliefs and behaviors related to photography. Face it: not everyone loves being photographed, and their reasons are as good as yours. You can

▶ **Marrakech, in the bazaar.**

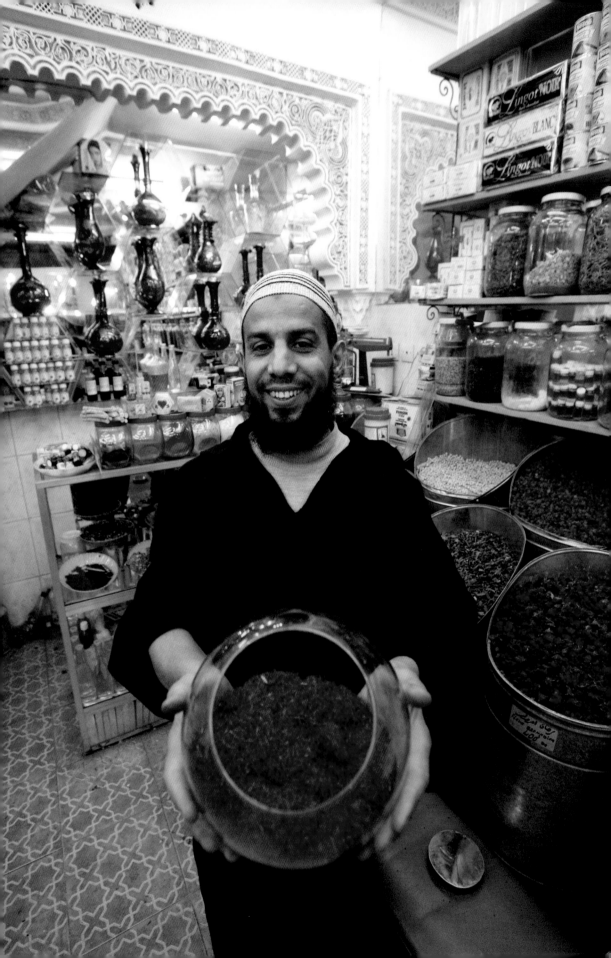

avoid a number of unpleasant incidents by respecting what's important locally. In certain cultures, some people are afraid to be photographed because they think you are stealing their soul. Other cultures consider exposure one of the greatest values. When I shoot reportage in the States, it frequently happens that people ask me to be photographed. In Europe, they are more reserved (actually, less and less) and I must be careful not to bother anyone. When I was shooting in Algeria, women were hiding from my camera and men were stepping in front of my lenses. When I am in India they often say "thank you!" because they love being photographed. Of course, this is only a generalization, on top of getting used to the local "photo-attitude," you must exercise sensitivity case by case.

Don't Be a Vulture

So, you have seen someone who would be interesting to photograph and you have the camera in your hands. Sometimes it's good to be fast and catch the moment before it's gone, but other times it's wise to wait. If you have the possibility to spend some time with the people you want to photograph, experience their company. Talk and interact with them, show respect, listen, be curious without being invasive, observe. Once you are part of the situation that you want to document, they will be more open to sharing their stories with you and your camera.

Look for Action

Dynamism looks good in a picture. Your images will look far more interesting if something is happening.

▼ Tailor in Kovalam.

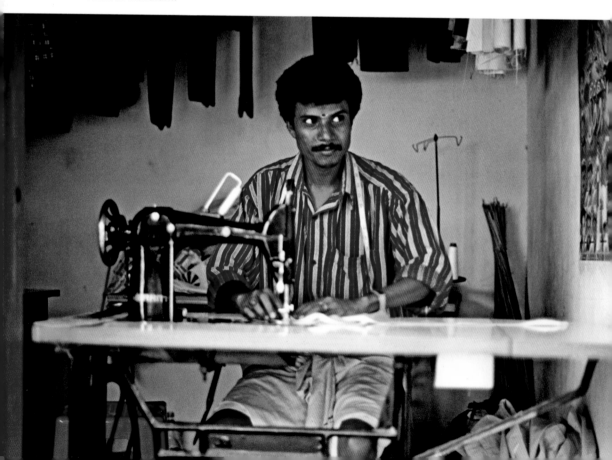

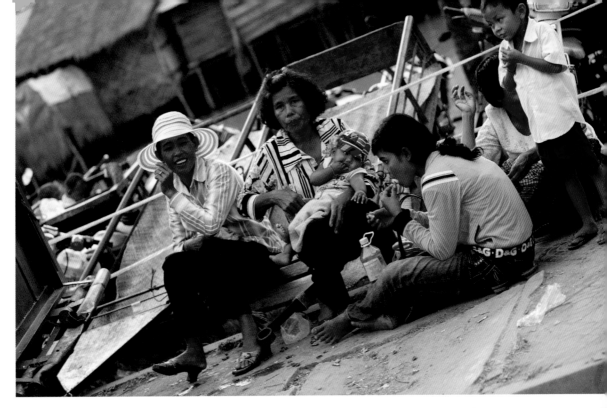

▲ (top) Siem Reap, on the street. Sit comfortably and become part of the environment that you would like to photograph.

▲ (bottom) Performer Odo7 backstage at the Imperia Lounge, Moscow. The ladies asked me not to shoot while they were getting ready, so I had to leave.

13. Pointing the Lens

Format

It's good to have a lot of material, so shoot as much as you can, but be sure to use your brain too. Your reportage must include pictures that can be published as an "opening" for the article; for instance, an aerial view of the place you are covering or perhaps a group image. These pictures are best if horizontal. In general, make sure to get both horizontal and vertical shots to make the work of the graphics people easier. They will appreciate it.

Diversify Your Pictures

You want to cover all angles of your subject. If you are photographing an event, in order to show the general atmosphere and the attendance, you need crowd shots. Look for a low wall or a stairway you can climb on to capture the crowd slightly from above. If you can't find a way to get a vantage point on the crowd through your viewfinder, just stretch your arms up and start shooting above their heads. Where possible, it's also a good idea to get an overview image that shows both the crowd and the setting to make the context clearer. You're going to have to step outside of the crowd to get this shot. You also need details—close-ups that show what could otherwise not be seen— such as the writing on a T-shirt or on the cover of a book, food on a plate, shoes, etc.

Then you can have a few intense portraits of the people involved in the story, some close-ups of whatever might be relevant, and several pictures that show action (these are always more interesting than empty spaces, unless empty spaces are the theme of your reportage). I personally like seeing people interacting with the environment, it adds some vibrancy to the image. On top of that, a human presence helps show the proportions of a location.

Portraits can be intimate and focus on the mood and the charisma of the person portrayed or include the subject's surroundings and give information on the context. Sometimes I know the person I am photographing because I had to interview them or simply because we had a chance to talk. In this case, I tend to use a 50mm or 85mm lens and go for an intimate portrait. I can ask the subject to sit or stand in a certain way, I can even adjust their clothes or hair a bit if needed. I usually choose to have a background that does not distract attention from the subject (i.e., a neutral environment or something without a lot of elements). If I don't know the person and/or the location is an integral part of what I want to show (i.e., a market, a festival, a cultural event, or a busy street), I'll opt for an environmental portrait and use a wide-angle lens. In this case, I welcome lots of details

◄ Environmental portrait in Shanghai shot with a 16–35mm lens. This picture shows both a person and the environment. Tilting the camera adds some dynamism to the image.

and elements. If I want to have a number of people in my image, I usually shoot several frames because chances are high that one or more of them will close their eyes, look terrible, or make a funny face. Getting a group shot in which everyone looks good or at least interesting is not easy, and sometimes mere chance is your best ally. If you know your camera well and are able to make technical decisions in the blink of an eye, you'll be more comfortable and you'll be free to focus on the composition of the picture or the interaction among the people. The capacity to compose your images quickly and intuitively comes with experience. The same thing applies when photographing strangers. Some photographers ask permission before pointing their lens at someone, others don't. I usually hold my camera and look at the person; I immediately get a sense of whether I am welcome or not.

The way you approach people is personal and unique. Each photographer should develop their own way of doing this so that they feel comfortable, are not invasive, and get good results.

On this topic, photographer Marlon Krieger wrote a great article titled "Knowing What It Means to Be Photographed (www.fuelyourphotography.com)." He points out how, even in the remotest places on the planet, people are increasingly aware of photographers, and it has become more and more difficult to get that candid shot. He writes: "People that would have once shown indifference to the camera by your side are all too aware and self-conscious of the power of the picture. Some ask for

▼ "What are those people doing in my picture?" Shooting this lava flow in Hawaii, I wasn't too happy about a group of explorers standing right on the spot. But I must say that the dark silhouettes added a sense of proportion to my image.

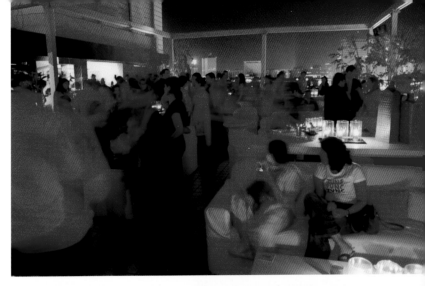

► Bollywood party in Bombay. I considered this image insignificant and I put in the "discarded pictures" folder. The magazine didn't like my choice, asked me to see all the pictures and chose this one to print on a double page. I must say that with the right graphics it looked really good.

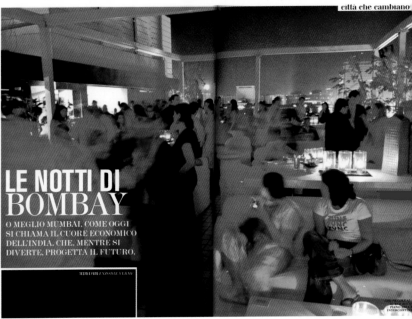

città che cambiano

LE NOTTI DI BOMBAY
O MEGLIO MUMBAI, COME OGGI SI CHIAMA IL CUORE ECONOMICO DELL'INDIA, CHE, MENTRE SI DIVERTE, PROGETTA IL FUTURO.

TESTO E FOTO ENZO DAL VERME

money, some sheepishly turn away, some even strike a pose, and others scream in rage at the intrusion on their privacy." Krieger underlines how photographers sometimes use predatory techniques and "people become victims of our cameras instead of us being unobtrusive witnesses and documenters." Remember what Mahatma Gandhi said? "I believe in equality for everyone, except reporters and photographers." Before your next trip, please Google Marlon's article and make sure to read all of it.

Hopefully sometimes you'll be able to capture a dynamism that suggests to the viewer what is happening beyond the limits of the picture. Two thumbs ups! A telephoto lens is handy to shoot without being too invasive, although—if you are clever—even a fish-eye lens can be used discreetly. You might have to shoot a lot in order to get only a few good pictures, and that's okay. What is not

okay is shooting one picture that would fit in an investigative reportage, another perfect for a glossy travel story, and another shot in paparazzi style. You need to have your angle clearly in mind before starting.

Another thing you want to consider is the season. Let's say that you found an intriguing story of local interest in France and want to shoot it in August. Forget about publishing it in November (a monthly

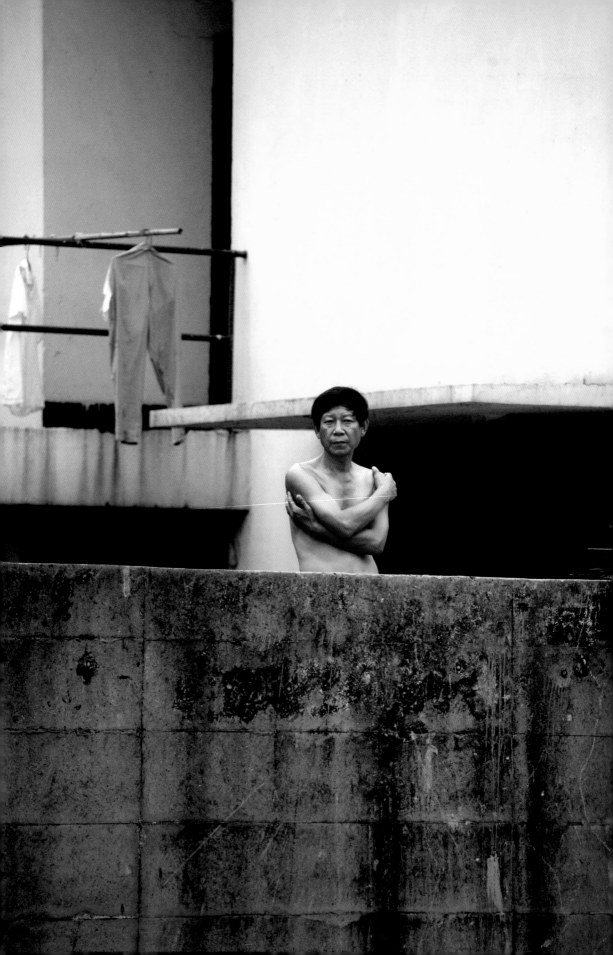

magazine needs the material two months in advance). The readers want to find current stories, and a picture with people in shorts and tank tops is not what's happening in winter. You might have to wait until late spring to publish it, but then your reportage might be too old already. A good rule is to avoid shots that appear seasonal. If your story is done mainly with portraits, that's okay because you can ask your subjects to

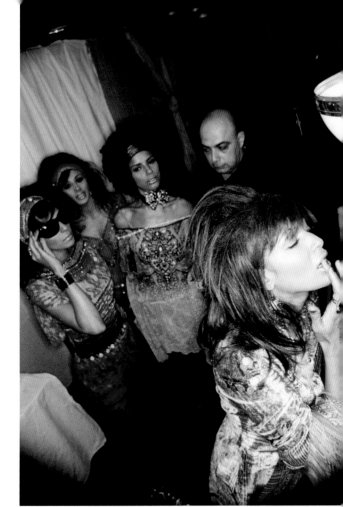

◄ "A picture is worth a thousand words." Laundry day: a naked man waiting for his pajamas to dry off. I shot this image around an abandoned steel mill in Shanghai.

► At times, photographers need to be invisible while shooting—as some say, "like flies on a wall." If your subjects need to be very concentrated on what they are doing, you don't want to annoy them. Shooting this fashion show backstage in Bombay, I used a wide angle lens so that I could catch the action of one person in the foreground and the setting too.

▼ Graffiti artist Speto in front of one of his murals in São Paulo.

◄ Light designer Peter Abdallah in Beirut, shot with a 16–35mm lens. ▲ I had been waiting a good 20 minutes in the same spot for someone walking in the park that would fit my picture. I had groups of kids passing by, big families, unsexy joggers . . . and finally, the right couple!

wear something appropriate. If your story must include pictures with a crowd, well, you better sell it to a weekly magazine. In any case, all together the photos have to tell a story and give the viewer a lot of (subliminal) information. Sometimes a didactic image works well; other times, putting too much information in your picture will have a boring effect. Better a symbolic image.

It's good to capture some close-ups of faces to show people's emotions: a nice big laugh, a look of surprise, and sometimes even tears. Covering an event, I normally use my 70–200mm lens for these images because it allows me to get the shot without being too intrusive. My personal rule is not to photograph someone's face if I suspect that publishing that moment would violate their privacy (yes, even if they are in a public space). Please stay away from producing tear-jerking pictures. I personally find that they drastically lower the level of reportage.

One more important thing: stay focused, but always keep your feelers up! It might happen—and very often it does happen to me—that while you are shooting your reportage you bump into another interesting story. Sometimes this other subject happens to be much more interesting and fresh than the one that brought you on location. Be ready to extend your stay or to squeeze more work into your days.

◄ Portrait shot with a 50mm lens. Pakistani ski champion Shahzad Rana in Oslo. In this portrait, the attention is all concentrated on the subject; the setting is neutral.
▼ The Pinacoteca, São Paulo. Which one of these two pictures is more interesting? A human presence sometimes adds some humor and a dynamic twist.

14. Misery Is Photogenic

Most features on the market cover tragedies, and editors' desks are flooded with gut-wrenching pictures. The lack of reportage on anything other than disasters, Third World tragedies, and exploitation of kids often meets with disappointment. Some editors (and readers) can't stand pictures of poor kids and the like any longer. But the market demands it, and photojournalism is there to reveal the ugliness of our world.

Some assert that disasters and misery are easy targets for photojournalists, especially when they are shot in the Third World, because you can get exotic images with a high emotional charge. Images of disasters closer to the First World (where the readers usually are) are not entertaining, they are scary. On top of that, in order to narrate in images a reality closer to the readers, you need to master the language of photography. That's more difficult.

Filthy dying kids photographed in a remote Third World environment seems to guarantee a strong visual and emotional impact. Apparently, that's why many photographers are busy with horror stories.

Documenting tragedies is right and proper—within limits. In my opinion, it is important to keep documenting what happens in our world, but there is no need to dwell on the runny, fly-infested eyes, or bloated stomachs of hapless kids. It is possible to narrate the same things while avoiding the pathos of pitiable and rhetorical images.

Professional photographers are not the only ones who feel compelled to point their camera at suffering; amateurs do it too. The favela photo-safaris are an expression of this trend. Tourists pay a guide to walk them through the poorest neighborhoods of Brazilian big cities so that they can capture the misery as a souvenir of their exotic trip.

As you probably already understand, I am not a fan of tragedy aesthetics, and I don't like the tendency to transform the afflictions of our world into an entertaining product or a trophy. I definitely prefer photojournalism that is inspiring. I like to explore solutions rather than problems. But it's not always an easy path: in the distressing panorama of today's information industry, anything not related to the celebrity culture or to a disaster seems to get very little space.

If we look at the winning images of World Press Photo, there is often an excessively spectacular voyeuristic dimension. For instance, the Jodie Bieber portrait of the Afghan girl whose nose was cut off by the Taliban is somehow similar to Steve McCurry's Afghan girl, just with a twist of horror.

Several photographers comment on the results of the World Press Photo contest year after year. The issue is very controversial and seems to touch a raw nerve among

many insiders. Russian photographer Vladimir Vyatkin, for instance, wrote a very mordant article, "What's Wrong with Global Photojournalism?" that every photographer should read. Regarding new photojournalists he stated: "Many of these adventurers appear to have no training in photography at all. Having grasped the basics of autofocus, they rush to portray human suffering, trying to find a niche in the hierarchy of international journalism" (http://rbth.co.uk).

If newcomers are looking for easy ways to impress the audience, the old schoolers stooped just as low. During a conference, Italian photographer Ferdinando Scianna related an anecdote from his career. He recalled the time he went to cover an earthquake and a fellow photographer on the plane took a doll with a smashed head out of his bag. The photographer confided that the prop was always in his luggage when he covered natural disasters so that he could place it here and there in order to add some drama to a picture. After narrating this episode, Scianna made his point of view very clear about the importance of seeing photography as a way to document reality and not a tool to create spectacular or tragic images. He also mentioned, among others, the controversial Kevin Carter picture of an emaciated and exhausted little Sudanese girl collapsed on the ground with a vulture nearby ready to move in (1993). Apparently Kevin Carter waited 20 minutes with his lens trained on his suffering subject, hoping that the vulture would spread its wings (it didn't happen) in order to shoot a more dramatic image.

Nowadays, with competition so fierce, photographers too often gratuitously add the right dose of drama when drama is missing. Another approach (which can easily go hand-in-hand with adding drama) is to make cosmetic improvements to war and tragedy pictures. Is this ethical? The debate continues to rage on in photography blogs.

▼ Kayelitsha slums, out of Cape Town in South Africa.

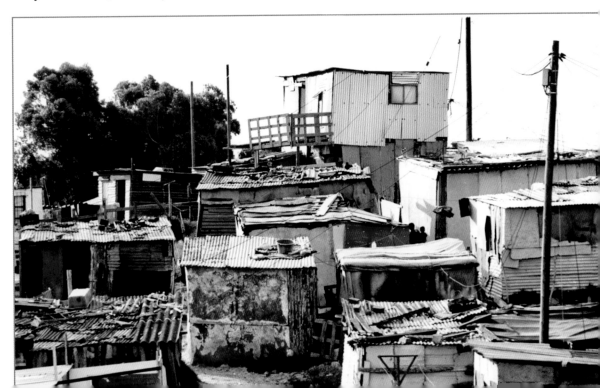

15. A Few Tips for Your Clicks

Train your eyes to rapidly scan the image seen through the lens of your camera. Besides that, there are several factors to take into consideration and many possible actions to chose from. Here's a little reminder:

RAW or JPEG?

I shoot my reportage work in RAW. Some people think that it's not essential because shooting in JPEG you can get files big enough for publishing. But I prefer having bigger files: the images are better quality and have more detail. Sometimes I want to crop a picture, and with a good original I can do it. When shooting in JPEG, I could crop only a bit. On top of that, shooting in RAW I have originals that allow me to print my pictures in large formats for exhibitions. The downside is that RAW files must be converted, and that is kind of annoying. (Well, technology evolves quickly!) Anyway, my suggestion is: always shoot in RAW.

Depth of Field

Most of the time, it's good to have a point of strong interest in your image: an action, a gesture, a person, a gaze, etc. The attention of the viewer will be drawn there. In a portrait, I always focus on the eyes and sometimes I deliberately use a shallow depth of field to enhance the intensity of the look. When I am not very close to the person I am photographing, I still try to have the subject sharp and the background blurred. If the subject is a group of people, I like having someone in focus and the other people out of focus.

The wider the aperture, the shallower the depth of field, and vice-versa. If you decide to explore this effect to the extreme, pay close attention to what you want to have in focus, or be prepared to have some funny pictures. Play with the various possibilities: sometimes it's interesting to reverse the balance and have an out-of-focus subject on a sharp background. Keep in mind that different lenses will give you different depths of field: a wide angle will allow you to see a larger portion of the image in focus and, on the other extreme, a telephoto will limit the focus to a small area of the photograph.

The Light

Shooting outdoors, you will usually find the best light just before and after sunset or sunrise. During those hours of the day, the shadows are longer and softer and the sunlight is gentler with a golden, warmer tone. The difference between light and shadow is not so strong and therefore your pictures will have softer contrasts. On the other extreme, shooting in summer on a sunny day, at midday, you will have very strong contrast. Of course, you can play with that

◄ The Palais Rhoul hammam in Marrakesh.

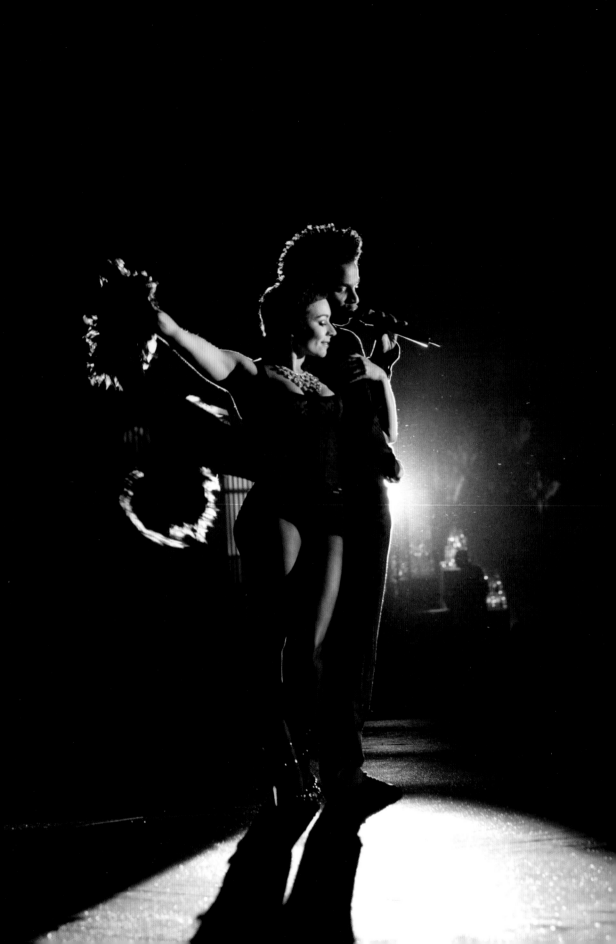

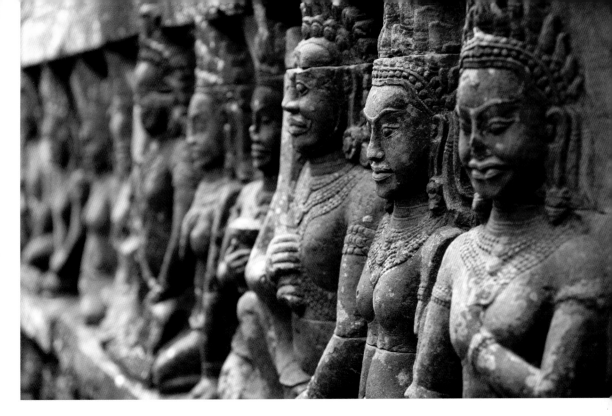

◄ The Ambrosia Dance Company. When the source of light is behind the subject it designs a rim light around it.
▲ Terrace of the Leper King bas relief, Cambodia. If the subject is a group of people (or sculptures!), you can have someone in focus and other people out of focus by playing with the depth of field.

and get a very interesting image, but it's not always easy. One of the problems is the fact that the shadows on people's faces are really strong and unforgiving. Flaws and imperfections are emphasized. To avoid that and brighten up deep shadow areas, you can use a flash. This technique is generally referred to as *fill flash*. Do it with caution: you don't want an image that looks surreal. A flash is also useful to brighten up a backlit subject. Personally, I use flash only in extreme or critical light conditions and try to adapt to natural light. That means that, if I have the time, I move around the subject looking for the best lighting and the most interesting background. Sometimes even sunlight in

the camera can add an interesting twist to your photograph. In any case, when the light source is behind the subject, it designs a rim light around it, creating an interesting silhouette effect. This effect isolates your subject from the background, thereby enhancing the point of primary interest in the picture.

Freeze or Blur Action?

Playing with the shutter speed allows you to freeze the action or heighten the dynamism of it. If you select a fast shutter speed everything will be still; if you opt for a slow shutter speed, moving elements will be blurred and still ones will be sharp.

Motion blur can add a sense of action to your image. To produce the effect, you need to have your camera still and use a slow shutter speed. Motion blur is often used in nature scenes with running water because of the nice contrast between the sharpness of certain elements and the movement of the water.

Panning is a technique that puts some speed in your picture. It works on moving subjects such as runners, cyclists, and cars. You need to set your shutter speed to $^1/_{50}$ second or slower and train your camera on your subject, following the motion at the very same speed. Once you are happy with the framing and composition of the image, keep moving and shooting. In your picture the subject will be still (except for the moving parts such as the wheels of a car or the arms and legs or a person) and the background will be blurred and striped. Panning is not very easy to perform, and you might need some practice to get it right.

Slow Sync Flash

Try this: if you are shooting in a pretty dark environment (e.g., a club) and there are a few lights here and there (little bulbs, Christmas lights, candles, even neon lights) choose a slow shutter speed and use your

▼ (left) Thriatlet Massimo Voltolina. Sometimes even sunlight in the camera can add an interesting twist to your image.
▼ (right) Cohors dance group rehearsal photographed with the panning technique. This picture was shot with a shutter speed of $^1/_{40}$ second. The dancer's arms and legs are blurred.

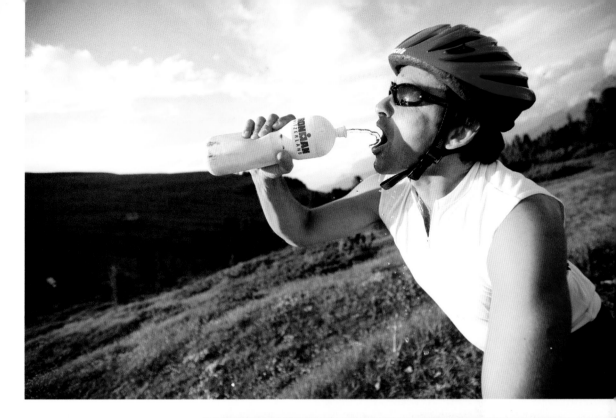

▲ Cycling training. Have a close look at the jet of water. A fast shutter speed was used to freeze the action.

▶ San Lorenzo columns, Milan, photographed using motion blur. This picture was shot with a 0.5 second shutter speed. The camera was resting on a bench. The motion blur technique needs the camera to be still; if a tripod is not available, any surface will do. The architectural elements are still and sharp, while the walking crowd is blurred.

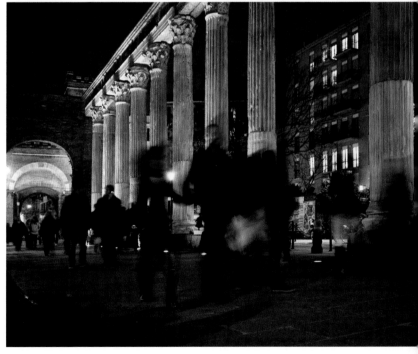

flash. You need to point your lens at one main subject and jiggle, shake, rattle, and roll your camera while you are shooting.

This way, the flash will freeze the subject and the small lights will create irregular trails on the subject and on the background.

Bracketing

Exposure bracketing (or auto-exposure bracketing) is a camera function used to automatically create three or more images with different exposures. Using this feature will allow you to capture detail both in the highlights and in the shadows. The effectiveness of the exposure bracketing depends on the range of tonal values that you have selected for the specific lighting conditions. The shots range from overexposed to underexposed and can later be merged in postproduction to obtain a High Dynamic Range (HDR) photograph (in other words, an image with a full range of tones, from highlight to shadow, with detail visible in the brightest and darkest tones). Personally, I am not a big fan of HDR imaging, but I recognize that it can create great images, especially in landscape photography when there is a huge contrast between the sky and the scenery.

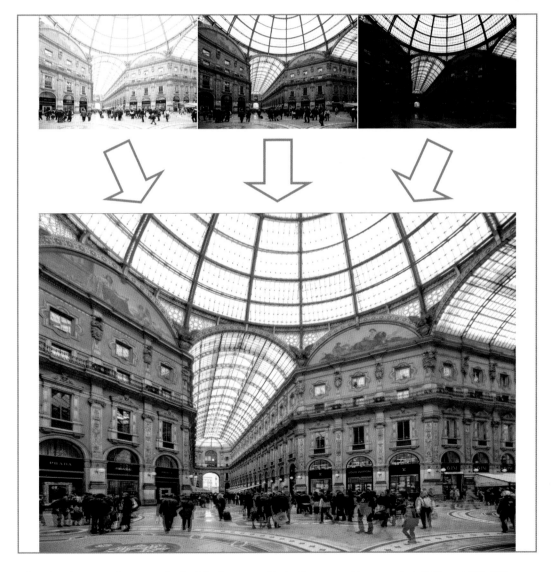

◄ Samba dancers photographed with slow sync flash. Exposure: $1/4$ second at f/10 and ISO 100.
▲ Exposure bracketing to photograph the Vittorio Emanuele II gallery, Milan. If you use Photomatix Pro to merge your pictures, you can choose from different options, including the reduction of ghosting (not used in the picture above).

In-the-Dark Exposures

Night pictures are usually more interesting when the sky is not completely dark, and so I tend to schedule those shots in the twilight. If you use a slow shutter speed, your camera will read more light than your eyes actually see and a cloudy sky can be spectacular, with no need for postproduction. Remember also that when you photograph outdoors after the sun has set, the sky color that you see with your eyes is very likely to look much more blue in the picture.

When you photograph for a travel magazine, consider shooting a couple of pictures during the "blue hour." They have a great impact, especially when the dark-blue tone of the sky is in contrast with the brightness of available light (see also the photograph on page 73). Not every magazine likes the effect. Once, an American interior design magazine told me that the pictures of the beautiful Bali residence shot during the blue hour didn't meet their editorial guidelines because they were too romantic. Oh well . . .

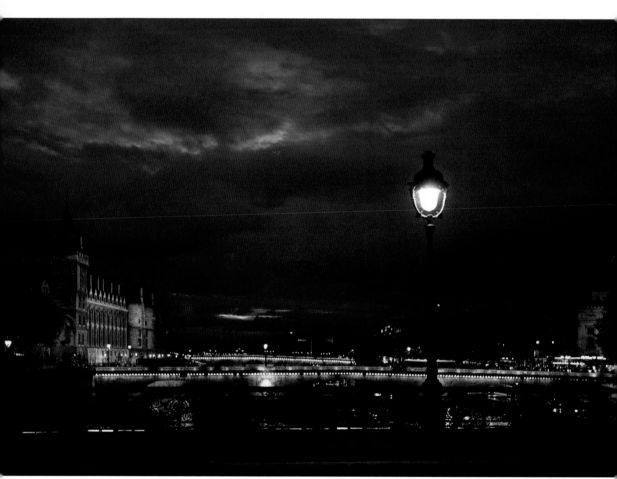

▲ Bridges on the Seine River shot at $^1/_{60}$ second and f/2.8. "Blue hour" starts 15–20 minutes after sunset and lasts about 30 minutes. A similar "blue hour" occurs in the early morning. It starts about an hour before sunrise and ends about 20 minutes before the upper edge of the sun crests the horizon.

▲ (top) The Indigo Bar in Bombay photographed without flash using a long shutter speed.
▲ (bottom) The Indigo Bar in Bombay photographed from the same point of view of the previous image, but tilting the camera and using the slow sync flash technique.

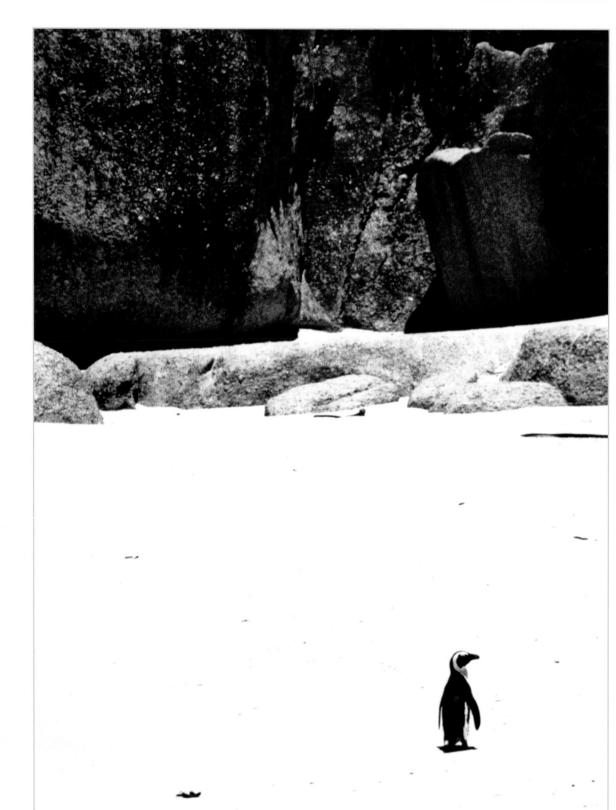

16. Composition

Photography books often list a number of composition rules, such as the rule of thirds, the golden section rule, diagonal rule, and framing rule, that tell you how to position the important elements in your picture. These guidelines are certainly interesting but, in my opinion, too many theories and notions in your mind might have a bad influence on your capacity to connect with the situation you are photographing. What I consider really important is using your gut and intuition, not a rule. Otherwise, as you try to squeeze an image into one of your composition schemes, your attention will follow the lines and weights and you will risk missing the essence of a moment.

Having said that, there are certainly a few tips I can give you on composition:

• Check the background. Your subject can blend into a busy background and disappear. If you can't shoot against a "clean" background, work with a wide aperture to keep the focus on the subject only.
• Leave some air around the subject. Yes, it seems useless because there is nothing important in that area of the image—but that's its strength. Incorporating negative space can draw attention to your subject.
• Play with the camera angle. A little twist can have a huge impact on the way the

scene is perceived. In portraiture, when you look up at someone you enhance their authoritativeness; when you look down on them, you might have the opposite result. You will make your subject taller if you are looking up at it and diminish its size if looking down at it. And who said that you can't turn your camera? You have endless possibilities in your hands. Remember that while an image that is slightly crooked looks wrong, an image that is totally crooked has style.

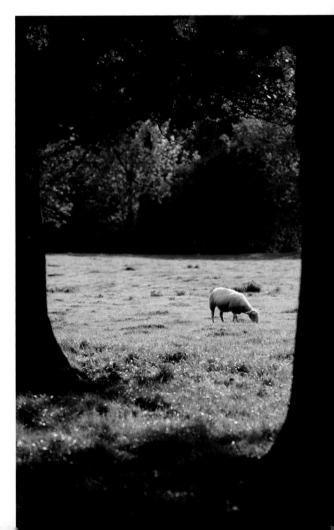

◄ Penguin at Boulders Beach. Some air around the subject gives more importance to it. ► These sheep were photographed around Abergavenny, in Wales. The trees serve as a framing device.

If you don't want to use that sort of idiom in your pictures, check the viewfinder to make sure everything is properly aligned. Also, especially when you use a wide-angle lens, make sure it is perpendicular to the subject to minimize any distortion.

- Balance your image using a mix of in-focus and out-of-focus elements, bright and dark tones, movement and stillness. Remember that a void is not empty and can create tension or balance the visual weight in a picture.
- Use natural elements (a window, an arch, two trees, a group of people) to frame your subject. The focal point of your image will be highlighted and you might get a better sense of depth.

- Position your subject off-center. The background talks.
- Focus on reflections in a pool, window, or a mirror. With this simple strategy, you can get peculiar and powerful images.
- Consider photographing from unusual points of view. I often put the camera on the floor or in places where I can't even get my eye to the viewfinder before pressing the shutter button. A viewpoint that differs from the usual human eye line can add a special twist to your image.
- Play with your lenses. If you have a wide angle and you get very close to some element of the picture, you get a lot of distortion. Have fun!
- Use diagonal lines to add some dynamism and a sense of depth to your photograph.

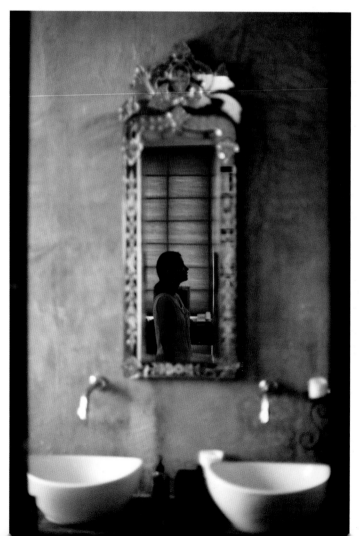

◄ Indian interior designer Divya Thakur was photographed in her house, reflected in a mirror.
► Portrait of psychotherapist Joy Isaacs, London. When you photograph someone from a low angle, you enhance their authoritativeness.

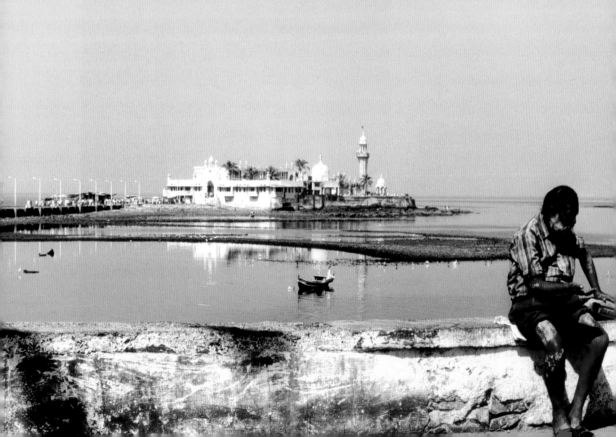

Incorporate horizontal lines to add a sense of stability and grounding. Use curves to create a soft spot in an image. Of course, there is nothing written in stone, and your results will depend on your subject.

- Check everything in the image you see looking through the viewfinder, including the edges. The impact of your composition depends on all the elements of the picture. If you are not totally convinced, find a better angle. Sometimes a little adjustment of your viewpoint makes a tremendous difference.

- Consider leaving some space for copy. This will make your photograph easier to use in a magazine. If you are wondering what I am talking about, open up your favorite publication and notice that the titles merge with the pictures. Sometimes the titles and captions appear on the pictures themselves.

◀ (top) This building in Cape Town was photographed with a tilted camera. Note the diagonal lines formed by the street and the reflection on the building on the right.
◀ (bottom) Beggar in front of the Haji Ali Dargah Shariff. The subject is off center, the background talks.
▼ Aroma Jockey ODO7 photographed in Moscow with a wide-angle lens. His hands were very close to the lens.

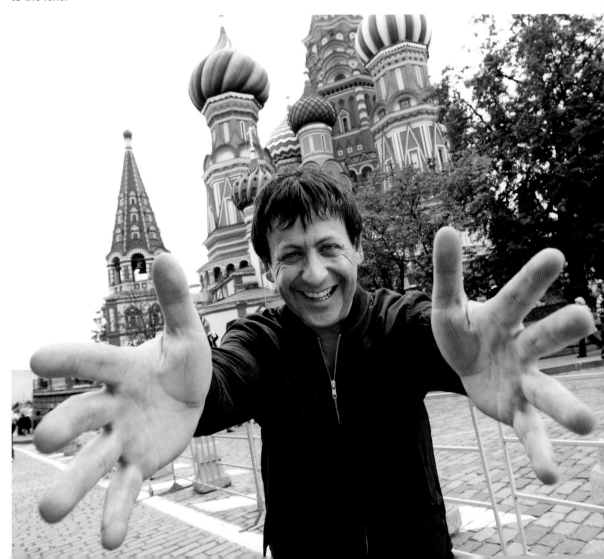

17. What to Shoot

You already know that your passion for the topic you are covering needs to be supported by a strong eye, a sense of light and composition, and the capacity to use techniques with promptness and flexibility. Now what? Your individual point of view is the added value that you are selling, so make sure to express it. You can, of course, shoot all the pictures of your reportage trying to emulate the style of the magazine that you work for, but that means letting your creativity atrophy. My suggestion is: keep in mind what the market wants and let your camera be guided by your intuition. What are you curious about? What are the shapes and contrasts that draw your attention? How do you feel in front of the scene you will capture in your image? Is there a situation that is attracting your photographic eye? Follow it. One easy way to have a fresh look at the world is to imagine you are an infant with no memories of similar events, no history, and no baggage. If you can do this, you will notice a lot of details that you would

▼ (left) Monk at the Angkor Wat temple. ▼ (right) Handmade crafts, Morocco.

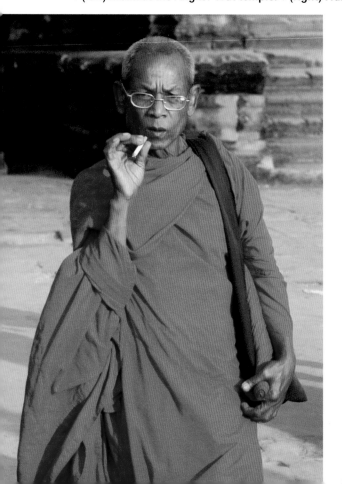

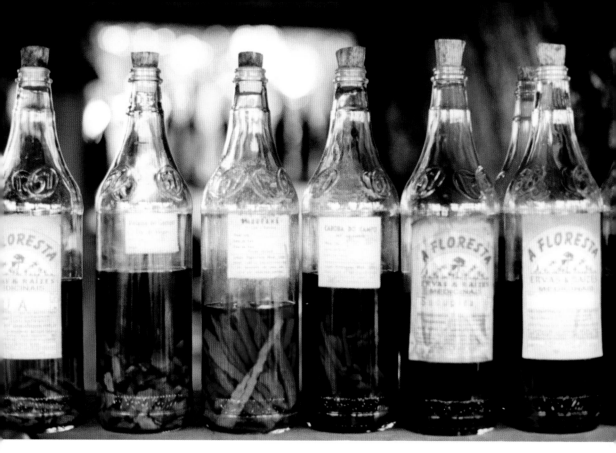

▲ **Bottles of cachaça flavored with medical plants. Itacaré, Bahia.**

otherwise miss because we tend to take for granted that we already know what we are seeing. At the other extreme, you are adult enough to know what can be published in a magazine and what might be considered unsuitable. And, of course, nothing will stop you from shooting a more commercial picture—or another shot that you will not give to your client but will enjoy creating.

Whenever you point your lens, be mindful of what you are framing or highlighting. The very same things in the very same place can be reported in many different ways. You are the one who selects and decides what to bring to the editor's office. But—and this is very important—you need to be fully

aware of what you have to choose from. This awareness grows best in an open mind and with a curious attitude. Train yourself to observe reality from different points of view. Sometimes things are obvious; a monk smoking like a cowboy who suddenly steps in front of you would make a great subject. Other times, the elements are much more subtle. If your mind is busy scanning the surroundings for something preconceived and specific, many things might pass you by. A selective mind is good when you need to stay focused, but you mustn't sacrifice receptivity for selectivity. And the more you take in, the better informed your final selection will be.

18. Out of Your Comfort Zone

When shooting reportage, there are situations that tend to push you out of your comfort zone, moments in which you might ask yourself: "To shoot or not to shoot?" or other similar questions. Personally, I happen to have doubts about a number of issues. I'd like to share a few examples with you.

Once I was in a semi-deserted subway car in New York at night, and in front of me sat a South American woman with her daughter. The mother was dreadfully tired. I imagined her going back home after a very long and hard day at work. She couldn't keep her eyes open and her big, depleted body was abandoned on the seat with her head hanging over sideways. Everything about her oozed exhaustion, except for her right arm, which held her daughter tenderly. The girl was probably 5 years old and lay on her mother's lap wearing pink overalls. She wasn't that tired, and from time to time she opened an eye and looked at me with a sweet pouting face.

The light was hitting the couple just perfectly and the entire scene was shouting to me "Shoot me, shoot me!" The camera

▼ Subway station in Harlem, New York.

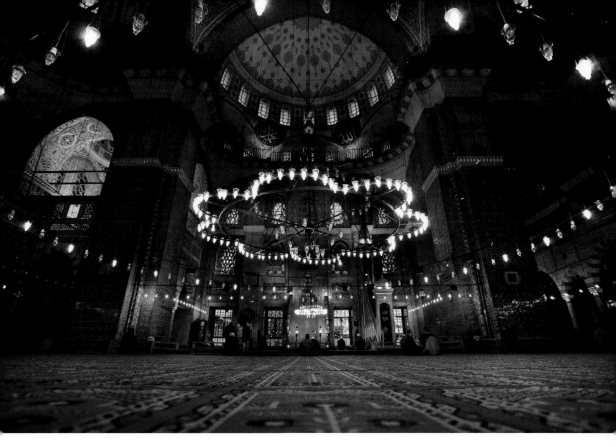

▲ Yeni Cami mosque, Istanbul. I shot the image when I was sure I would not disturb the praying.

was in my bag, and it would have been easy to point it at them, but I decided to enjoy the moment and respect their privacy. In the following days, I kept thinking about that missed opportunity: Was my fear of being too invasive completely founded? Maybe they would have even enjoyed finding themselves published on the pages of a magazine. Never mind; I am happy to have that wonderful memory, even if I can't share the picture. Episodes like this actually help me to be more clear about the way I want to relate to the world—*not* as a vulture.

Challenging moments can also come up when I am supposed to photograph someone who becomes unavailable at the last moment, or when I am shooting outdoors expecting a sunny day and it rains, when I am discussing an assignment and I realize that I will not get what I need, and when a magazine publishes one of my stories in a distorted way—in other words, when the world seems not too kind to me. But if I look well into the issue, I usually find that it is not only the practical problem that makes me feel uncomfortable, but also and above all my inner reaction to it. Facing and exploring what's there in that particular moment (sometimes a fear of whatever) allows me to transform the problem into a great learning opportunity.

I invite you to do the same. When you do so, even the most challenging situations will have a different flavor.

19. Deep Throats

Sometimes your work will become much easier if you hire a local. In certain areas where photojournalists commonly visit, you'll find people who specialize in this kind of service. If you log on to Lightstalkers.org you can ask fellow photographers to advise you and recommend a "fixer" for a certain place. Otherwise, search online on other sites while preparing for your trip. You can also simply look for drivers locally. Tourist guides are often a very good choice, but that is not necessarily always the case. It is essential that the person that you pay to help you knows the area very well and has good contacts.

Every now and then, you'll find it really hard to achieve a good result without the support of (paid or unpaid) locals to show you around, introduce you to the right people, tell you what you need to know, and provide practical tips. Besides a paid fixer, there are other supporters, for instance:

- those who genuinely desire to help show you something that they really care about, usually because they want your reportage to have a good impact on the public (they are the best)
- those who want you to photograph them (why not? but are they pertinent to what you are doing?)

- those who do very little for you and then give you a hard time asking to see all your pictures, to check over what you wrote, or to get a number of copies of the magazine (*Tip:* Always make it clear that you don't have total control over what will be published and that sending magazines to everyone is an expense that you can't afford.)
- those who won't do anything for nothing: a dinner, a favor, etc. (I often invite my supporters out for dinner, but when I see that they really expect it, I get annoyed.)

In any case, acknowledge and be grateful to every single person who is helping you out. See if there is any way you can support them. People are not there to be used by you for your reportage. On top of that, regarding the people that I photograph, I always try to do it in a way that they are happy about. It's their image that is going around. Despite what I just wrote regarding people asking for copies, I always try to give the magazine to the people involved. If there are five or six of them, it's doable; if there are thirty or forty (as often happens), it is unfortunately not possible. Sometimes I don't send the printed magazine but a PDF by email. In this case, I can send as many as I want. Most editorial offices are okay

► **Sex worker in Bangkok.**

about giving me a PDF of the article; others don't want to waste their time helping me to make my local contacts happy. The staff in an editorial office are usually busy people, often stressed out by hundreds of requests. It's important to keep relations with them smooth. If I sense that my request is inappropriate, I don't insist and instead create a PDF by scanning the pages of the magazine. Sending the published reportage is not the only way to thank the ones who helped me out, and if I know of a contact or piece of information they might need, I try to send it to them.

▼ (top) Art gallery opening in Shanghai. ▼ (bottom) Kovalam Beach in Kerala, India.
▶ Traffic policeman in Alger.

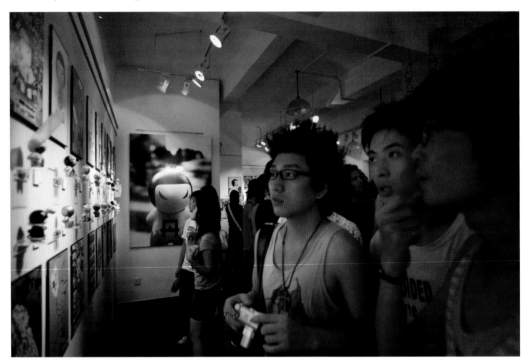

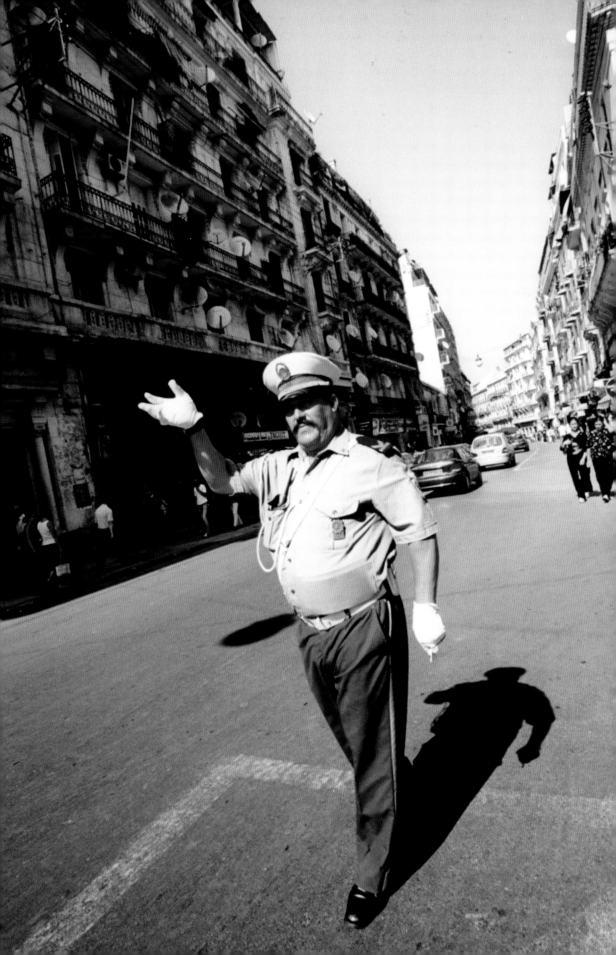

20. Shooting, Shooting, Shooting

So now you have already been on location for a few days, your deep throats are giving you plenty of information, the weather is just right, and you found out that the best lighting for a panoramic picture is at 4:30am, the best moment to photograph another spot is around 6:30pm when it is really crowded, and after midnight you have a fantastic night view from a hill reachable only by driving one hour on a dirt road. What's next? Go through all of your images and check them out. Are they harmonious, or there is something that you wish you had photographed in a different way? Maybe

you still have time to do so. Now check out all of your contacts: how many people do you still have to meet? How about that one whom you couldn't squeeze in? Relax for a moment and see if there is anything that you might add to your work to give it a special twist. Did you go to the top of the tallest building to shoot a panoramic view? Is it the bell tower or a private house? Some of your deep throats might know the sacristan or the supervisor with the keys to the terrace. How about going back to the main square, standing in a corner, and waiting around for interesting people to pass by or

▼ Souvenir pictures taken in Paris and Algier.

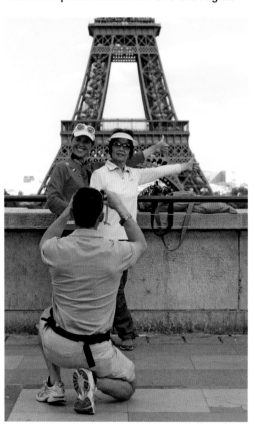

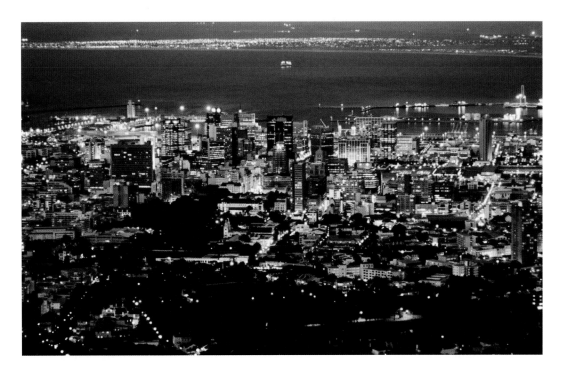

▲ Aerial view of Cape Town by night.

something to happen? You could do this: spot a really nice location (if not the main square, a street corner with a curious neon light, a colorful market stall, a beautiful tree, etc.) and just stay there. You might want to look for a nice angle to point your camera from and relax. Hopefully, a couple holding hands will pass by, a barking dog will run across your field of vision, or a motorbike will arrive. Be patient and your picture will compose itself before your eyes.

How many details have you photographed? Sometimes they are very important in the description of a certain situation or issue. Are your shots describing the topic of your reportage well? Are they intriguing, warm, and funny, or are they kind of cold? Is there any action, dynamism, surprise?

What would your clients say? Would they be satisfied with what you are doing, or can you imagine them saying "Very nice, but . . . "? Most importantly, are *you* satisfied with your work? Forget about your clients for a moment. What is the picture that you didn't dare to shoot? Maybe you can find a way to take that picture.

Do you have enough information for the text? Time is running out and now is the moment to plan your last shots. If you feel that you have what you need and you don't have to postpone your flight, be grateful that your camera didn't break, the weather was with you, there were no strikes, assaults, or flood and you didn't get the flu or food poisoning. Sometimes you get all those things in less than one week. If you are professional, you get your reportage done anyway. Anyway, certain things like a marathon, a general strike, and the Ramadan can be known in advance. Always check the calendar and the news to be prepared. Unforseen events will happen anyway.

21. Coincidences

Now I want to give you a few examples from my own experience on how unplanned events can be one of your best allies.

True, you better check all the information sources you can in order not to have too many surprises that might block your production. True, you want to be ready and schedule your shoots. But it's also true that many things simply can't be scheduled. Be curious, stay open to whatever unfolds around you, and enjoy the serendipitous thrill of chasing coincidences: they'll take you somewhere.

The following episodes happened during my reportage in Abruzzo, but I could have picked any of my other trips and found several interesting examples in each of them.

The very idea of shooting reportage in Abruzzo originated by coincidence. It happened at the end of one of the workshops that I teach a couple of times per year.

We were getting near the end and, as often happens, there was a lot of excitement and enthusiasm among the participants. One of them, an Italian-American, asked me if I would be interested in leading a workshop with a group of American photography students. He and his wife had been able to enroll in my workshop late because I'd

▼ View of the mountains around Calascio.

had a last-minute cancellation (what a coincidence!). My workshop had been sold out for over a month already.

At first, I wasn't sure if his proposal was only dictated by the enthusiasm of the moment (students always leave the workshops with lots of inspiration and ideas for new projects to work on) or if he was really serious about it.

He was serious. A few weeks later, we started working on a workshop tailored to a group of students from the School of Visual Arts of New York. His idea was to bring them to Abruzzo, a region in central Italy with an area of about 11,000 square kilometers and a population of 1.3 million. Nature is breathtaking there, but tourism is not really developed and very few people visit that part of Italy. He had in mind a specific area where many of the villages had lost all of their inhabitants through the hardships of farming and grazing. However, thanks to the determination of many of the locals, abandoned small towns had been reborn—especially one of them, where former farming properties are now being used to provide distributed hospitality (pricey lodgings are scattered among local houses) in a rural setting. The reception desk is in a cave where they used to keep pigs, and the style of the rooms reflects an austere and frugal way of life.

The villages in the area are all nearly abandoned and have a special charm. The traditions are preserved and people live very much according to the rhythms of nature. My student, Paolo, imagined that American photography students would be thrilled to

▲ Castel del Monte captured in the "blue hour."

have the opportunity to find themselves in such a beautiful place for a workshop.

He had a visit to Rocca Calascio in mind, the highest fortress in the country, and also wanted to revel in the past in the medieval town of Castel del Monte, considered to be one of the most beautiful villages in Italy. I wanted to check in person how to schedule landscape shoots under a variety of lighting conditions. Additionally, we wanted to meet locals and see if we could arrange portraiture sessions with local artisans and craftspeople, getting a look at traditional methods of embroidery, ceramics, pasta-making, etc. We wanted to visit shepherds and learn about their traditions, see if they would

have been happy to meet photography students. We wanted to explore the hilltop villages of San Stefano, San Bartolomeo, and also Castrovalla (now 18 inhabitants only), once visited by M. C. Escher, who created a famous etching of it.

We decided to visit that particular area of Abruzzo with the help of Lorenzo, a local guide (in fact, the best guide you can dream of). We planned to go location scouting and meet artisans and farmers who continue to work at their ancestors' trades. While we were on our way to this spectacular place to organize the future workshop, I thought about taking the opportunity to shoot reportage with the "Italian village rescued by rural tourism" angle. Of course, I also needed pictures to promote the workshop and show potential students what they could photograph if they decided to join in.

We were supposed to go there in June; the weather would have been just perfect. Lorenzo was waiting for us and everything had been organized. Guess what? At the last moment, something happened and I couldn't go! Paolo went on his own and his initial reconnaissance was very useful for organizing the workshop, but I couldn't shoot my reportage on abandoned villages reborn. Of course, then Paolo had to travel, I had to take care of some urgent shooting, and winter arrived! Everything was telling us that it would have been nuts to go there at the end of November—it could have started snowing any day. But we took the risk, and the weather was with us! Actually, I found more interesting light conditions than I would probably have found in June.

After a couple of days there, we realized how hard it was to meet people. The villages

▼ Lorenzo Baldi, the best guide you can dream of!

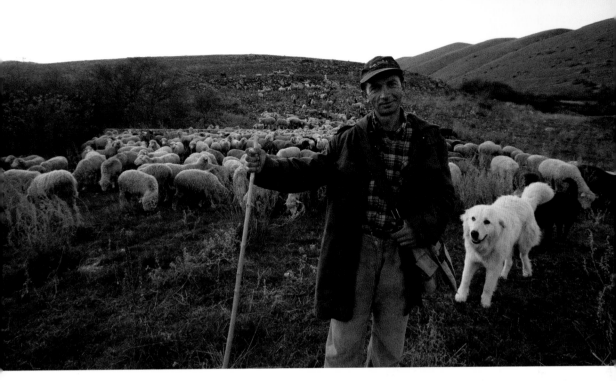

▲ Zili is from Albania and moved to Abruzzo to work as a shepherd, a job that not many young locals are willing to do.

were remarkably empty. Where could we socialize with locals? We decided to head to Castel del Monte, which was larger than the other villages. It was so big, in fact, that it boasted three restaurants! It was the end of the day, and we were tired and wanted to eat. One of the restaurants was closed, so we tried the second, but the owner had to turn us away immediately: there was a special dinner for a group of locals invited by the pharmacist. She wanted to thank them for their help in setting up a local branch of the Red Cross. We went to the third restaurant, where we were the only guests. After a plate of lentils (typical local farm product), Lorenzo and Paolo launched the idea of going back to the other restaurant and asking

if there was anyone who would fancy being photographed while making pasta, crocheting, or working at the loom.

As we entered the restaurant, people turned a silent stare upon us: who are those three men? We introduced ourselves and said what we had to say. The response was lukewarm, "You want to shoot pictures? I don't want to be photographed. Maybe her . . . " "Who, me? No, no, no . . . "

Not far from me, there were a few teenagers. I looked at them asking for help with my eyes while saying, "Are they really that camera shy?" One of them whispered to me: "Of course not! They all love being photographed, but they enjoy being won over first." Okay. After a very entertaining

45 minutes or so chatting with the people in the room (all of them women, except the priest), we left with an appointment for the following day with several of them.

I knew that one of the local handicrafts is crochet, so I thought about photographing a woman busy crocheting. How could I photograph her? Close to a window to get nice light? In front of a fireplace to add some homey warmth? Sitting on a chair outdoors? The first person we visited in the morning was Silvana. She surely knew how to crochet and would be happy to show me her skills, I thought.

We arrived at her home and couldn't find her, then we saw her out in the garden. She

was busy with big flowerpots and piles of wood. "Oh, you are here!" she exclaimed loudly, "Right in time to chop wood with me." Chop wood? That was so much nicer than crocheting! "Yeah, I need to feed the stove. You see, if I don't do this, I have no wood ready and my house will be cold. Plus, wielding the axe is good exercise for me." Silvana was a tough woman, very much in control and proud of her resoluteness. I asked her to hold her axe and stand in front the door of what probably used to be a stable and was now used for storing tools, wood, and other things. She looked very comfortable. It was easy for me to photograph her in what looked like her element. After the shooting, she recalled that the previous evening we had spoken about local craftsmanship. "You see," she said, "not every woman is into crocheting." Bang. Serendipity is the word that indicates the knack for making fortunate discoveries by accident and finding things we are not looking for. Some would call it coincidence.

After an intense day of shooting (full of discoveries like Silvana's axe-woman-ship), we still hadn't managed to photograph one of the most intense-looking women we had met the previous evening. I really insisted

on the phone with her, but she said she was not interested. Not even Silvana managed to convince her! We were in the car heading to a different village, when we suddenly saw her right in front of us walking on the street in our direction. We stopped to say hello. She said she had been at the cemetery to salute her loved ones that had passed away and that she wanted to get ready for the evening procession. Procession? We found out that, once a year, the inhabitants of the valley gather in the village of Barisciano where they take the statue of Saint Flaviano out of the church and walk all around the village praying. What is the word here? Synchronicity. If we had passed by one minute before or one minute later, we would have never known about the San Flaviano procession. And—wouldn't you know?—we managed to be around on the only day of the year we could witness this unique event. So we changed our plans and headed for Barisciano. Luckily, I still had some taralli with me (sort of ring-shaped breadsticks typical of the certain regions in central Italy) so we could count on a few carbs to give us energy for the following hours. We arrived there about an hour before the beginning and immediately asked for information: what route would the procession take? We walked the entire route, and I looked for things I could stand on in order to get a slightly raised vantage point on the crowd. There were low walls and staircases that suited my purpose. I climbed up and checked the composition in the viewfinder. One spot was almost okay, but there were numerous trash cans in the way. Another

▶ Saint Flaviano procession in Barisciano.

one was better, but there were visible billboards in the background. Farther over there was a ruined wall I could climb where the view on the street was not too bad, but there were too many parked cars. Luckily, I was able to find some better spots, especially one where I needed to scramble up a rugged bit of abandoned field and position myself on the edge of a wall right in front of a tree. Taking care not to get scratched by the brambles, I could compose an image that would include the typical local architecture and the crowd passing by. There was also a street lamp that I imagined would help me to get a nice atmosphere in the picture. I was right. That's where I shot the image that you see here. The procession moved along at a pretty brisk pace, and I had only a fraction of a second to get the right

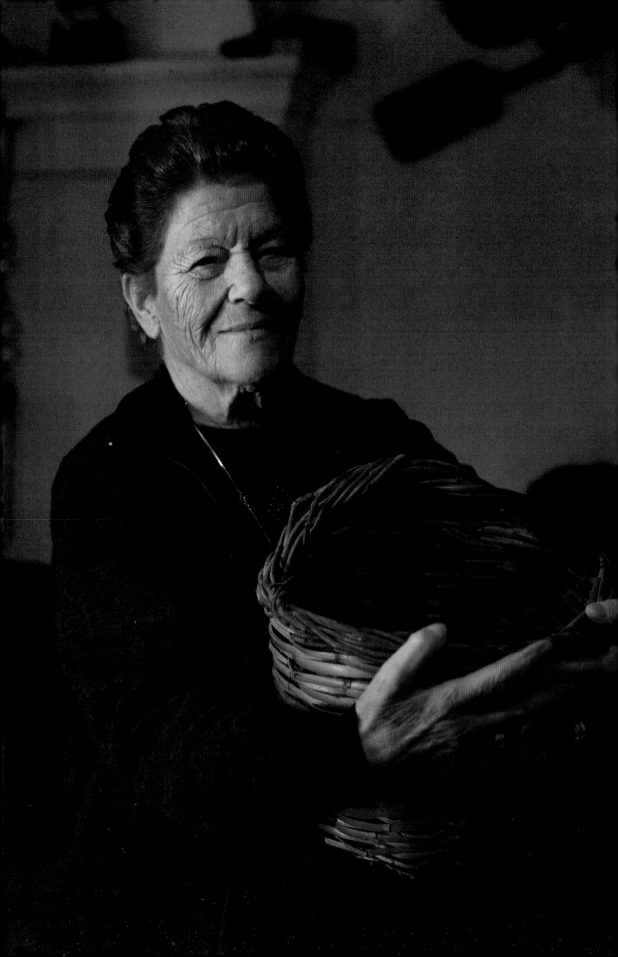

shot. Once the statue was almost under the street-lamp, I opted to shoot three images in a row. Of course, I also followed the procession from the beginning to the end and I shot several other pictures. I was the only photographer around. Also Paolo shot a few images, but he was far more discreet than me. Locals were obviously not used to having outsiders intruding on their celebration, and at a certain point a man asked me what I was doing. I told him that I was shooting reportage on how they preserve traditions, and he was almost surprised. "Take good pictures of us," he recommended. Everything went on fine. Even the two policemen stopped staring at me once they saw me talking with the man and him being cool with it.

Was the day over? No way! I had to write down all names and the main captions and organize the pictures that I shot during the last hours into folders. Of course, we also had to plan the coming day. Oh, and the next morning we wanted to photograph the dawn, so we had to set the alarm for a super early wake-up.

Things kept unfolding this way. A plan, a coincidence, a change of plan. Another plan, another coincidence, another change of plan. I could list many other coincidences that shaped my shooting days in Abruzzo, but at this point I imagine you have an idea of what I mean when I say that unplanned events can be one of your best allies.

◄ Bruna holding a traditional basket. ► (top) Elia lives in Castel del Monte, one of the biggest villages in the area. She says: "Here we have everything: the church, shops, a kindergarten, a chemist shop, and now even an ambulance. We don't use it much because people are healthy here, but in case we need it we have it. For serious cases, the helicopter is coming. Of course, if your time has arrived, the helicopter is useless." ► (bottom) One of the rooms of the Sextantio Albergo Diffuso.

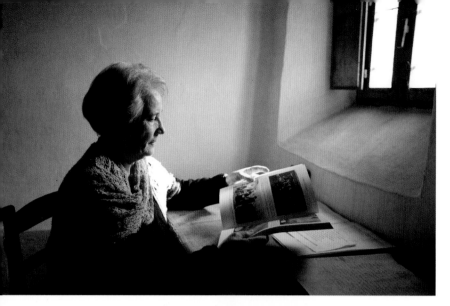

◀ Lina is a retired teacher who has been transmitting to several generations—among the rest—her knowledge on local traditions and history.

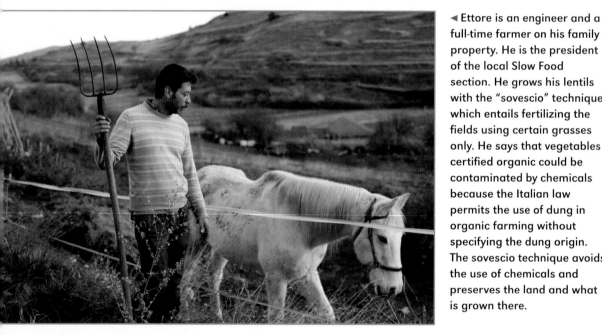

◀ Ettore is an engineer and a full-time farmer on his family property. He is the president of the local Slow Food section. He grows his lentils with the "sovescio" technique, which entails fertilizing the fields using certain grasses only. He says that vegetables certified organic could be contaminated by chemicals because the Italian law permits the use of dung in organic farming without specifying the dung origin. The sovescio technique avoids the use of chemicals and preserves the land and what is grown there.

◀ Rocca di Calascio.

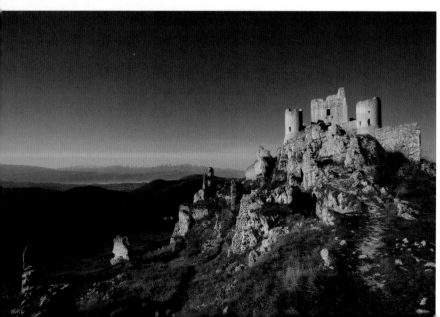

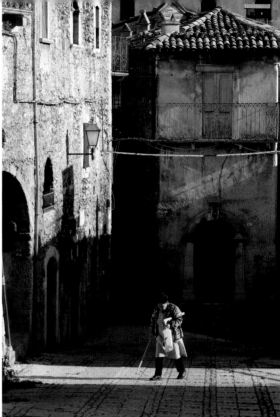

▲ (top left) The door of one of the rooms of the Sextantio Albergo Diffuso. It's called Diffused Hotel because the rooms are not in one building but all around the village in former shepherds houses and stables. ▲ (top right) Calascio, bringing home wood for the heater. ▲ (bottom) View from Calascio.

22. The Model Release

Always bring model releases with you. You will ask each person that you portray (note that I am only talking about portraits here) to sign one of them. The document states that the individual gives you the right to publish their picture and that they will not demand money for that. Laws vary in different countries; one of my clients not only wants a model release signed for editorial use but prefers that I use one of her company's legal documents. In general, for editorial use you don't need model releases for pictures that contain several people in a public place, unless there are minors in the shot. I know, starving African kids don't sign model releases, but if you take photos of minors in France, things are a little different and magazines will not publish their pictures in order to avoid legal problems. (Does this mean that the rights of citizens of wealthy countries are better safeguarded even in the realm of image usage rights? Yes it does.) You also don't need a signed release for photographs of celebrities or well-known people shot in public places (because their image is public and not private), unless your picture shows them in a way (picking their nose?) that could damage their reputation or disclose embarrassing facts about their private affairs. This topic is actually open to different interpretations: what is gratuitous damage of reputation and what

is right of information? In any case, most of the time you will not have to deal with celebrities, and it is good to make things clear by having your model releases signed. I like to keep things simple. The one I use is not too detailed (people get bored or suspicious if they have to read a long document) and says in a clear way what needs to be said. If you photograph someone in his/her house, add a few words to make it clear that they also agree that their property will be shown. Under the signature, I ask them to note their phone number and email address for quick contact. It can happen that a magazine will ask you for that portrait several years later, and in that case, you might want to inform that person.

Even if the signed model release gives you the legal right to use his/her image, diplomacy and good manners are always welcome. My clients are mainly in Europe, and they take it for granted that I have a signed model release for every person I portray (of course, not for casual crowd shoots). I know of photographers who never ask to sign a model release for editorial use. It's a choice. Anyhow, this is one of the most highly debated topics, and apparently there is no one big truth, only many points of view.

There have been cases in which, once the picture was published in a magazine, the

◀ **Leesa and Laura Andrew in New York.**

person photographed complained and there was no model release signed. The photographer proved that the person was present in more than one shot, posing for the camera, so the complaining was unjustified. Still, it's always better to avoid disputes. A few written words will make the relation clear:

I the undersigned . . . born in . . . on . . . residing at . . . authorize the use and reproduction by [your name here], or anyone authorized by this person, of any and all photographs taken of me and my property during the photo shoot in . . . on. . . .

With this, I release [subject's name here] from having to give me any compensation for my services and/or for the rights of using my likeness.

Read and approved [subject's signature]

I am neither willing nor in the position to give legal advice. What is sure is that if you sell one of your pictures for commercial purposes (advertising), you *must* have a model release signed for each and every person in it.

Here are a few links where you can find model releases for advertising:

http://asmp.org/tutorials/forms.html
http://contributors.gettyimages.com/
 article_public.aspx?article_id=2722
http://www.alamy.com/contributor/help/
 image-releases.asp

There are many iPhone and iPad applications available that you can use to create model releases. I still haven't tried them and do not feel the need to do so.

▼ High-society party in Bombay.
▶ Amanda Lepore in New York.

23. Interviews

A photographic reportage can be great, but without good text it is difficult to publish. I usually deliver the total package to my clients: pictures with detailed captions and an article that often contains interviews (this is more interesting to read than a mere description of the facts). When you are shooting your reportage, you need to schedule time to interview people. Your story on the eco-village in Iceland will be more interesting if it contains the portraits/interviews of the founder(s), a few inhabitants, a couple of experts, and maybe someone who is not completely in agreement with the project or even criticizes it. You need to ask them their stories, how they feel now, what they have gone through, what their future projects are, and to share funny anecdotes and anything else they might like to share. You will get information from people not only during the interviews but every time you talk to them. Take a note and always remember to ask them if they would feel comfortable if you were to publish what they shared with you off the record. Your subjects and anyone else involved will be very annoyed if you publish in your interview things that they were not willing to make public. That's why every time I interview someone and I hear something that sounds like an important statement, I stop the conversation and I repeat the exact words to the person that I am interviewing: "You just said blah, blah, blah. Is this what you want me to write?" Sometimes they feel more comfortable rephrasing the sentence and I feel more comfortable too. There are reporters who record the interviews and then write them down later on. At times I do it too, but I find it very time consuming and I do too many interviews to use this method. I prefer writing notes on my laptop while the person is talking; this way, I can always check if everything is okay as the interview is proceeding. If we don't have much time, I might omit some details. That's why I try to read the interview as soon as possible (usually the same night) and add some comments while my memory is fresh. On top of the interviews, make sure to collect figures and numbers from reliable sources to use in the article when you write the final version.

► Moscow, on the street.

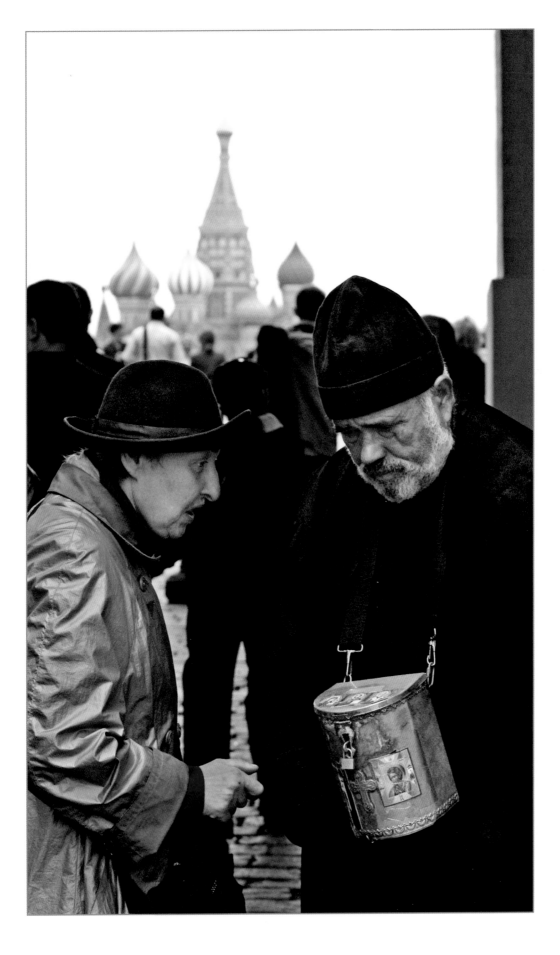

24. The Editing Process

You are back home and just want to rest from all the intense shooting, but the work is not over. Not at all! Open the "first choice" folder and go through all the pictures you've just shot. Now it's time to do the real selecting. Photo editors don't want to see hundreds of images that look alike. You might have to re-start this process over and over until you are sure that what you are going to present has a good impact. If you can't decide among two or three similar pictures, keep them all. Once you are sure about your choices, convert the RAW files you have selected into high-resolution JPEGs and create an OK folder. For better quality, you could also convert RAW images to TIFFs and then convert them to JPEGs just at the end. Magazines want JPEGs. Open the OK folder (I use Adobe Bridge) and compose the story giving an order to your images. I start with the horizontals that might be used for opening the article, then I drag the pictures around until I find a good sequence. In the process, I might realize that something is missing. In that case, I search in my "reserve" folder to see if I can find what I need. Sometimes a not-so-interesting picture can be saved with simple cropping. Once distracting elements are removed from the corners of the frame, your composition will appear cleaner, much to the viewer's advantage.

Now it's also time to open the two or three similar pictures that you couldn't decide about and make your final choice. Seeing them big on your screen (for re-touching, I use a 30-inch monitor) will help you to identify small but substantial differences. Maybe one image is slightly more in focus than the others, maybe the expression on one face is happier or more intense. At this point, it will be obvious which one you want to save. Once you are done with this preparation, you are ready to open your pictures one after the other and retouch them in Photoshop. Besides dust reduction, the first thing that I usually look at is the framing that might need a little cropping or rotation. Then I check the colors, I fix the brightness, the contrast, and so on. Purists say that a photo should not be retouched; I personally find that approach anachronistic. If I shot, let's say, a view of a garden for a tourism article and I realize that there is a piece of paper on the grass, I have no problem erasing it. My apologies to those who think this means I am manipulating reality.

Your pictures also need to have all the captions and information added. Part of the job can be done with a batch action, but part needs to be done one by one. Open each image in Photoshop, then go to File>Info and fill out the form. You can write a lot of information in every picture.

To me, the essential fields are the author, description, keywords (at least a few), copyright status, copyright notice (I write: Copyright (C) Enzo Dal Verme all rights reserved) and URL info copyright (your web address). In the description field, try to write an interesting caption with all the verified information you have. Be mindful to be 100 percent accurate and always double check the spelling of names, streets, people, events—everything.

Last but not least, you need to name your images. I usually put the subject first, followed by a progressive number, and then my name—for example, Iceland-eco-village-001-Enzo-Dal-Verme.jpg. Now your pictures are ready to be delivered and archived. (*Tip:* If you have time and no one is breathing down your neck to deliver your reportage, forget about your pictures for a few days and let them rest. Then go back to them with fresh eyes. You'll be amazed how many details you will spot that you missed before. You might have been so concentrated in creating a nice sequence and choosing the best shots that you forgot, perhaps, to check if there are color dominances. Double-check everything.)

An Example of Editing

When I sit at my computer ready to create the final sequence with the images I shot, I usually start with a panoramic view or something that can give a general idea (overview) of the subject of the reportage. Then I add the other pictures, organized by topic.

I am now going to give you a couple of practical examples of editing from my São Paulo tourist reportage. I went there on assignment, and my task was to photograph what's cool in São Paulo—clubs, restaurants, shopping and, of course, "secret" addresses that only insiders know. A magazine doesn't want to publish what anyone can

▼ On the Backwaters, Kerala.

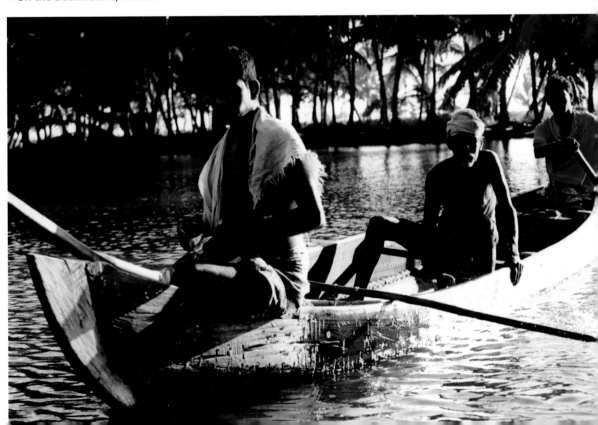

TORRE JOÃO SALEM

▲▶ On Avenida Paulista I looked for interesting corners to photograph. To exaggerate the distortion, sometimes I put the camera on the ground and shot a quick picture just to check the composition. When I was happy with the composition, I waited for people to pass by, and when they were in my frame I snapped the shutter. Buildings are nice, but people add dynamism and life to an image. Since I couldn't look through the viewfinder, sometimes I shot several pictures in the same spot because I knew that afterward, looking at them, I would see details that I had no time to check while shooting. Here, I prefer the first (top) image, and it is the one the editor chose to publish. In the first image, there is a group of people walking (dynamism). In the second image, the subjects' feet are cut off, and the man's black trousers get confused with the background . . . not good.

▲ Sometimes I also waited for cars, motorbikes, or bicycles. For instance, photographing the MASP (São Paulo Museum of Art), I decided to keep the exposure a bit long so that things passing by would be blurred against the static architecture. I used $1/40$ second exposure. Since I was walking around without a tripod, in order to minimize the shaking of the camera I spotted a tree to lean my back on and I held my breath while clicking the shutter (sometimes I get the same result by resting the camera on a guardrail or trash can). I stayed there for a while and shot several images with varying amounts of movement in front of the building. Then, in postproduction, I looked at all of them on a big screen, and it was clear that some of them were more appealing and others had to stay in the reserve folder.

find in a tourist guide, which means that I had to spot and report the trendiest place to go for an aperitif, the underground show that everyone wants to see, the new restaurant with a special twist, the hippest party in town, and so on.

Luckily enough, I had been to São Paulo several times already and I knew many people there, including a couple of very dear friends. They were kind enough to show me around and give me tips on where to go. Of course, I also had to shoot something well known. The challenge there was to show it in a new way.

One of the first places I photographed was the Avenida Paulista, its skyscrapers, and the couple of baroque coffee baron villas that were not torn down when the others were. The area has had a massive verticalization over the last 50 years or so, and it's not easy to photograph those tall buildings without distortion, so I opted to use distortion as a style! Of course, I photographed indoors and outdoors with the same approach and I played with a wide-angle lens. I also used other lenses; otherwise, it would have been too much.

I photographed the MASP on a quiet day to show its structure. I went back on a Sunday morning when there is a flea market. Silver, home-décor objects, antiques . . . in a certain corner they even do a sticker exchange (yes, Panini soccer player stickers). It's a collector's mecca. The building looks totally different on Sundays because the street-level space, which is usually empty, fills up with people and stalls. So visiting twice was the best solution to get both the

building and the flea market. I shot using mainly a 70–200mm lens, and in postproduction I selected images that would show people looking at stuff on sale with different kinds of involvement and expressions. I also

▼ I selected these three pictures to open the article. One of them, the aerial view on Igreja do Calvário in Vila Madalena (center), São Paulo, was published at the end of the article.

selected a few images with the objects on sale in focus and the people out of focus.

Photographing the infamous Bar Secreto (yes, Madonna swapped spit here with a Brazilian hunk) wasn't easy. First of all, it's not a place where you get in if you don't know the doorman. Secondly, it's definitely not a place where you walk in with a camera and start shooting. I managed to be introduced by my friends to one of the DJs, and that was the best key to enter. I positioned myself right behind the DJ, planning to get in the frame both her and the crowd dancing. How long was I there? Too long. I was shooting in slow sync flash mode, but the lights were hitting my position only every now and then, so I had to wait. On top of that, the crowd was not very colorful, and they constantly turned their backs on me. I

▲ (top) Bar Secreto.
▲ (bottom) Circus school students' show.

was there, in the best-possible spot to get a great shot, and I kept shooting horrible pictures. It was a nightmare, but I wanted that picture badly and I just stayed there. When the DJ changed, I had more chances. This guy was moving around a bit more, and at one point he gave me his profile while a group of people in the crowd turned toward us and the lights hit my camera. Bingo. The result is not a great picture, but when I saw it during the editing, I was super happy.

Selecting the images of the circus school students' show was not easy. They perform on Monday nights at the neighborhood sports field in Rua Belmiro. When I arrived, the place was packed mainly with the artists' friends. I managed to get in. I was lucky because a lot of people were out in the street watching through the fences. Anyway, I had

◄ At the MASP flea market I shot a few images of the objects on sale and others showing people looking at the merchandise. I chose the ones that had the most impact at quick glance.

my standing place and there was no way to move around. The audience was surrounding the artists, so they were performing in every direction and often had their backs to me. When I looked at the artists performing, on the background there was a big wall with a colorful mural that in the camera was getting confused with the action happening in front of it. During the editing, I looked for pictures with the artist closer to me so that they were not merging too much into the background. I tried to crop a few images to see if I could keep the atmosphere and dynamism of the evening while cutting away the noise, but I wasn't happy with the result so I selected only a few images.

São Paulo is famous for its wide range of restaurants, and I visited some of the newest and more interesting ones. I always photographed the location, the chef busy cooking, and a few dishes. A picture of an empty restaurant is not very appealing, but paying guests are not necessarily happy to have a photographer around. The solution was shooting a quick picture when there were guests at the tables while trying not to annoy them. Most of the time, the result was pretty boring. In the final selection, I was tempted to include only what seemed to be visually most interesting, but, knowing the art director of that magazine, I also included other images that I didn't particularly fancy. I was right; his final choice was very different from what I would have chosen, and the pages were looking fine. He played with big and small images and inserted captions here and there. He was happy with my work, and I was happy too.

▲ The Yam restaurant, São Paulo.

▲ Recipe by Ana Luiza Trajano, chef at the Brazil a Gosto restaurant, São Paulo.

▲ Recipe by Fabio Barbosa, chef at the La Mar restaurant, São Paulo.

25. Not Only Pictures

A magazine is interested in your pictures also because of the story, and you need to give them text that contains as much information as possible. There are (always more!) editors that simply buy some pictures from an agency and then look on the Internet for something to write about. The result is very poor quality and, at times, even misleading. I don't like this kind of journalism, and my clients appreciate the fact that I bring them first-hand information. I started writing for magazines before becoming a professional photographer, and so I feel pretty comfortable with the text. But this is not the case for everyone. Most photographers are not writing articles and they simply deliver text to be used by the editor as an outline. If you want to get more work, learn how to deliver good text. Editors love it when they get the complete package. You might want to team with a writer, but that would double the travel expenses and you'd also have to split the pay. Keep in mind that the "ingredients" needed are the famous five Ws (and one H):

- Who (is involved)?
- What (is happening)?
- Where (are we)?
- When (did it all start)?
- Why (is it happening)?
- How (are things happening)?

◄ (top) Rice fields in Bali.
◄ (bottom) Ayurvedic dish.

I would also add:

- How much, how long, how many? (data and numbers on the matter)

If you have no writing experience, leave the task to them. Every magazine has its own style anyway. Be mindful about the length and the structure of what you deliver. A magazine that is publishing pretty short articles with practical tips and addresses will appreciate it if you organize the information in that direction. A magazine that publishes long and in-depth articles will expect totally different material.

To ensure I have good relations with my clients, I try to understand their needs and bring them images and text as close as possible to their editorial line. At the start of my career, I was so enthusiastic about what I was finding that I bombarded my clients with interesting but unrequested information. Now, I am more diplomatic.

When your text and the interviews are ready, add a list with the captions for each and every photo. Yes, if you did a good job, every file already contains the description in the metadata, but you want to speed up the work of the editors. They love it when they get everything they need well prepared and easy to look up. Now archive in a folder your model releases, the business cards you have collected, the local newspaper articles that have been so precious for giving you extra information, the leaflets, booklets, and anything you used to gather the details of the story. That little treasure, soon or later, might be very useful again.

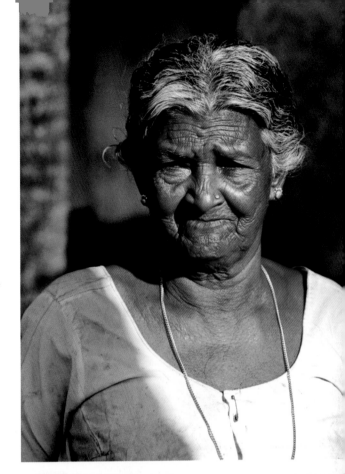

▶ (top) Woman in Vizhinjam.
▶ (bottom) Monks in Bangkok.

26. From the Idea to the Published Feature

The following example will give you an idea as to what might happen between the first time you think about covering an issue and when you see it on the pages of a magazine.

One day, a friend told me about a volcanic woman entrepreneur who had staked everything on creating a new model of sustainable social enterprise. She managed to set up a bag factory in prison to give a second chance to detainees and new life to scrap fabrics. How interesting! I contacted a number of the editors-in-chief of the magazines that usually publish my work, but their responses were lukewarm, so I decided to contact Luciana Delle Donne directly.

I explained to her that no magazine had commissioned me to cover her project, but I was confident that I could publish it. I proposed that I come to visit her. She accepted, but warned me that shooting in a prison would not be easy. I needed to request authorization, and there was no guarantee that I would get it.

After five months, I was granted access to the women's wings of the Lecce High Security Prison to shoot my reportage on the "Made in Carcere" (Made in Prison) project.

I didn't know much about the prison. Actually, I didn't know much about prisons in general, but during the shooting I learned many things.

When I got there, I only had access to the workshops. The cells—as one prisoner told me—are "three paces by two paces" with one single bed and one bunk bed in them. If one of the three prisoners wants to stretch her legs by walking those three paces, the other two need to lie on the beds because there is only a very narrow passage between the beds. Prisoners are confined to their cells except for 2 hours a day when they can go out into a small court with very high walls. Many prisoners try to kill themselves; others ask for "the therapy": strong psychotropic drugs.

The prison is not a very happy place. During my shooting, I heard women screaming and crying. But when I photographed them, I preferred to capture their smiling side. Then I asked them, "Do you think I am wrong? Do you think I should portray your desperation?" They seemed to be happy to be photographed while smiling. One of them told me, "Actually it would be more accurate if you could also photograph our cells. Most women do not have the same chance we have; they have to stay in their cells 22 hours a day. If you could show that in your pictures, people would see our smile but would also have a better idea of our reality." Unfortunately, it seemed to be impossible to get a permit to photograph the cells.

▶ **Made in Carcere, the tailor workshop in the prison of Lecce.**

computer . . . I had to give up. On the other hand, why should an instructor, who is poorly paid, come to work in such a difficult setting? And anyway, there are 6 instructors, psychologists, and criminologists for 1500 detainees. Among other things, they also have the task of determining whether I am a danger to society. How can they determine that if they've seen me 4 or 5 times in the 5 years and 6 months that I have already served? And the health services don't work either. Every time you have some pain

▼ (top) A more intimate view of the tailor workshop in the prison of Lecce.
▼ (bottom) Najib, one of the helpers at Made in Carcere, out of the warehouse.

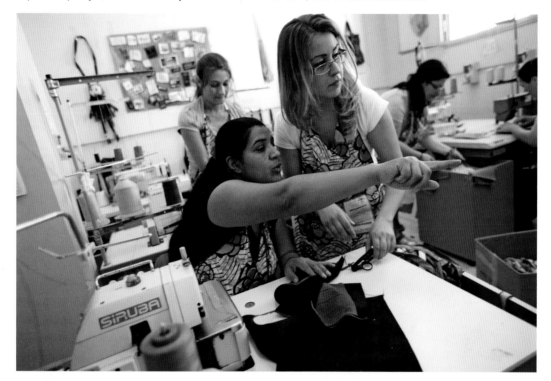

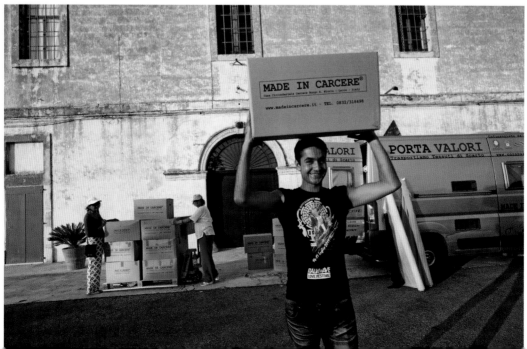

▲ These portraits of Luciana Delle Donne belong to the smaller set of images that I showed to clients only after the first set was sold.

they tell you it's anxiety and all they have for you is psychotropic drugs, pain killers, and antidepressants. If you're lucky, there's some tachipirina [paracetamol], but not very often. A prison like this just makes you a worse person, it doesn't rehabilitate you. And then, into this desolation, a sewing shop arrived where, in addition to a job, we

learn the rules of civil conduct. Even the most indomitable, if they want to continue working in the sewing shop, have to develop the ability to talk about things using a language that's different from the violent idiom of prison. It takes time, there are moments that are not easy, but when we all work together we can manage. Luciana has taught us that nothing gets thrown away, that everything can be recycled or reused . . . we detainees too. And she's right; we see it day by day. The success of our sewing work is a lesson in civil education for everyone. I am proud to work for Made in Carcere, and I would like to continue even after I have served my sentence, because a prison that rehabilitates is an advantage for all of society. The people who are imprisoned today were your neighbors yesterday and they will be again when they get out."

▲ (top and bottom left) Prisoners learn a job that will sustain them once they'll be released. Out of the prison, in town, there is an office/workshops where former detainees can find work.
▲ (right) One of the Made in Carcere bags.

27. Exposure Doesn't Pay the Bills

Recently, I received a letter from someone who claimed to be a student seeking to publish her research on a certain celebrity. She was very excited, telling me that she finally found a small publishing company willing to publish her booklet.

As I happened to have shot some portraits of that celebrity, she was asking me if she could use (free of charge) one of my pictures for the cover. The booklet, she assured me, was totally nonprofit, published only for scientific purposes (scientific?).

As a formality, she also enclosed a release: two pages of perfect legalese clearly prepared by a lawyer. I was asked to sign away my unlimited worldwide rights to my photos.

This trick reminded me of what happened with a famous brand. The head of the marketing department wanted to publish my interview in their newsletter. After interviewing me, as a final insignificant formality, he asked me to sign a similar release.

If they ask you to sign the rights of your pictures away for free with similar subterfuges, please be very mindful and don't fall for it. I know that these requests have become almost ordinary now, but photographers need to be paid for their work.

Magazines are selling copies and also selling advertising on their pages because they have interesting pictures and texts. Content makes a magazine valuable. That content is essential for their business. Without it, they could not make any money. That content *must* be paid for. Period.

Advertising agencies use pictures to sell products. Those images are essential to attract clients. Those pictures *must* be paid for.

If you are an amateur photographer, that's not a reason to mess up the market for the professionals. Please don't give your pictures away without compensation.

As digital democratization spread, anyone with a digital camera (or mobile phone) could convert life into pixels and call themselves a photographer. Consequently, the number of wannabes willing to give away their photos for free exploded. No wonder magazines are offering publicity and exposure instead of real money. This attitude is killing photojournalism. I can never say it enough that work needs to be paid for. And when one of my students says to me, all excited, that maybe such-and-such magazine will publish his/her pictures, the first thing I ask is "Did you negotiate a price?"

Clients that would like to use my pictures for free, or those who are only willing to pay peanuts because I will get "excellent exposure" really wore me out. In order not to waste time explaining each time why professional photographers cannot work for free, one day I decided to create a short cartoon that illustrates the facts with a bit of humor

(it always helps!). It's a dialog between two bears representing photographer and client. I posted the cartoon on YouTube. The title is *Exposure Doesn't Pay Bills*. To all those "clients" who are asking me to work for free, I am now sending a simple link to the video. Feel free to use parts of the following text to answer weird requests or use this cartoon to educate your clients.

This is the dialogue:

Bear 1: Hello photographer!

Bear 2: Hello client.

Bear 1: Photographer, I love your pictures!

Bear 2: Great.

Bear 1: I have got some work for you.

Bear 2: Lovely.

Bear 1: We need to shoot a really great, great picture. It will look terrific in your portfolio.

Bear 2: Wow!

Bear 1: The budget is limited.

Bear 2: I see.

Bear 1: There is no budget for the photographer.

Bear 2: I see.

Bear 1: But it's a great way to start working with us!

Bear 2: I see.

Bear 1: Lots of future work.

Bear 2: More free work?

Bear 1: We'll sign the picture with your name.

Bear 2: Of course you will, if I am the one shooting it.

Bear 1: And you will get fabulous exposure.

Bear 2: Wow! Will I be able to buy a camera with this exposure? Will I be able to buy new lenses with the exposure you are offering me? Will I be able to pay my rent with the exposure you are offering me? My insurance?

Bear 1: ewwwwww . . .

Bear 2: My computer? My software?

Bear 1: You'll get great exposure!

Bear 2: Exposure doesn't pay bills.

Bear 1: This is a great opportunity.

Bear 2: Is this work supporting a small charity run by volunteers?

Bear 1: No, it's for a luxury brand, but the budget is limited and we have some great photos in mind.

Bear 2: Are you working for free too?

Bear 1: ewwwwww . . .

Bear 2: Well . . . why should I do it for free?

Bear 1: I told you, you will get great exposure!

Bear 2: I see. Would you ask your plumber to work for free? Your mechanic? Your doctor?

Bear 1: ewwwwww . . .

Bear 2: Why do you ask a photographer then?

Bear 1: But you only have to click on the shutter!

Bear 2: The photo you want me to shoot would only exist because I've invested time, money, and energy to develop my capacity to create it.

Bear 1: Oh my!

Bear 2: Being a professional photographer involves a big monetary investment. We need to buy cameras, lenses, computers, software, storage devices, and a lot more. Things became obsolete fast. Things also break and need to be repaired. But this investment is nothing compared to all the risks that I have taken and all the time and experience I spent to learn how to do what I do.

Bear 1: Oh my!

Bear 2: Creating images requires technical ability, efficiency, promptness, creativity, taste, sensitivity, and several other skills that need to be developed over time. Getting credit and exposure isn't compensation. If I create an image, credit is my right, not something that you grant me.

Bear 1: Ouch!

Bear 2: Sometimes, I do offer my work to a charity of my choice. I love it! I think everyone should contribute to a good cause. But this is not the case. Sorry client. Please get back to me when you have something fair to propose.

28. The Future of Storytelling

For over a decade, I have been traveling the globe extensively in search of stimulating stories and interesting people to photograph and interview.

I got my biggest fulfillment knowing that my reportage could inspire the readers of a magazine and, sometimes, support a good cause.

The reason why I have been working all those years mainly for fashion magazines is both practical (they could pay for my work) and subversive. I have been able to give space to issues that do not match the latest lipstick color. Nevertheless, my stories have been published right on those pages, waiting to capture the attention of readers principally focused on cool fashion tips.

Don't get me wrong, I am not a crusader. I am simply curious and terribly fascinated by the variety of experiences and points of view present on our planet.

I hear you saying, "That's right, why should we narrow our minds keeping our attention focused on the very same stereotypes?" As most people working in the information industry know, the answer is distressingly simple: magazines are not information media, they are advertising containers. They are telling you—each one with its very own style and angle—that *if* (you vote for that candidate, you buy those shoes, you drink that water . . .), *then* you are going to be happy. And the boundaries between news and advertising are increasingly blurred.

Curiously enough, the vast majority of the public seems unaware of how much they are being manipulated by the media and driven to an insatiable hunger for the next thing that promises happiness.

Certain topics are not really welcomed by the mainstream press because they might disturb the advertisers (or politicians). In most cases, even the adding of some gloss will not boost the likelihood of seeing the reportage published; other times, the content gets manipulated, distorted, and glamorized by the editorial staff in order to fit the container.

How come painters of past centuries used to paint saints all the time? Because they were sponsored by the church.

People working in communication know well that the content transmitted by traditional media *must* support the advertisers. The reason is simple: without advertising, traditional media could not survive.

British reporter and former Journalist of the Year Nick Davies is the author of *Flat Earth News* (Vintage Digital, 2011). The award-winning book extensively analyzes falsehoods and distortion in the media, describing what he calls "the mass production of ignorance."

What is the point here? Advertising not only heavily influences the information industry, it also fuels it with its investments. When the advertising money drops, content producers are the first to be penalized.

I must admit, I have been privileged to be able to support my career almost entirely through projects that I was curious to explore. But recently, something happened.

An ailing economy, added to the impact of the Internet on the information system, caused the not-so-slow decline of traditional media. Many magazines and newspapers are facing closure. Everywhere staffs are being downsized, and articles are created by cutting and pasting press releases or quotes found on the Net. Photos are downloaded from some microstock agency site. Who still has the money to pay for stories collected around the world? Not many.

Yes, traditional media is in deep trouble, the number of assignments is shrinking, and photographers are forced out of their comfort zone.

At the same time, the number of photos available on the market increases every day. As a consequence, prices are falling. Where are those pictures coming from?

Nowadays, anyone with a camera (or maybe just an iPhone) can shoot some pictures, manipulate them to make them look more appealing, and post them online. Are they technically acceptable? Do they have a style? Are they consistent in narrating a story? Apparently, it's irrelevant. If they cover something interesting, they might even be used to illustrate news. They are fast, cheap, or maybe free.

These 21st-century "photojournalists" are happy to turn their photos into pocket money. There are agencies specialized in selling images by amateurs for $5 or less. Other agencies are shamelessly advertising: send us your pictures, you might see them published! And they sell them without giving to the amateur any other compensation than fame.

As a result, to make a living from quality photojournalism has become impossibly difficult. Some think that if you want to be a photojournalist, you'd better have a second job.

Life magazine photographer Jim Pickerell published a controversial article in *Black Star Rising* titled: "Sorry, Photography Students, But It's Time to Find Something Else to Do." Among other things, he states, "It saddens me that photo schools are preparing students for a hobby, not a career."

Picture agency boss (former head of Magnum Photos in New York) Neil Burgess already proclaimed the death of photojournalism in 2010, saying: "I believe we owe it to our children to tell them that the profession of 'photojournalist' no longer exists. There are thousands of the poor bastards, creating massive debt for themselves hoping to graduate and get a job which no one is prepared to pay for anymore."

Is the situation really that dramatic? Yes, it is. At the same time, photography isn't dead, but there is the need for a new business model. Crowdfunding has been explored as a means for supporting quality photojournalism. So far, the results are not encouraging.

The shift of photojournalism from mainstream media to online image sharing platforms is making it so that anyone can publish anything anywhere. What sort of credibility does that material have? A magazine or a newspaper is usually trusted because of its history of providing truth. Even if mainstream media do have their angle and do manipulate news, content needs to get the approval of an editor-in-chief and a photo editor. It is carefully curated. The current situation is bringing about a huge revolution. There is a big benefit: news that used to be censured now has a chance to be seen. But we also have a big disadvantage: hoaxes can be spread really easily.

As a consequence, content creators do have a new responsibility: build a reputation as serious reporters. Their content will be trusted and appreciated more than the content of someone else with no reputation. We don't know how long this phase of confusion will last. For sure, photographers who are able to keep their feelers up and monitor the mutations of business models will be rewarded. Apparently, in this evolutionary process, only those who are able to adapt and evolve will survive. My personal recipe is to differentiate. Even if I shot almost exclusively reportage in one period of my life, right now I shoot both editorial and commercial photos. Portraiture is my thing, and sometimes I do fashion too. My pictures are sold in art galleries and from time to time I teach a workshop. This way, I can afford to be busy with a photojournalism project without depending on it to pay my bills.

◄ Ivan, one of the young interviewees of my reportage *Eurogeneration,* photographed in Amsterdam. *Eurogeneration* was shot all over Europe and explores the lives of people who were born in one country and are completing their studies on the other side of the world, thanks to student exchange programs. They end up living somewhere in Europe, maybe after trying out two or three other places. The Eurogeneration reportage was shot on assignment a while ago. Nowadays, no magazine would send me to 6 different countries to shoot a feature.
► Banned! A while ago, a group of American women got together with the idea of redefining the concept of beauty. Men can be blond, brown, red, white and *bald.* Why not women? They were very active organizing cultural events and conferences. I photographed them in New York as they were that day. No makeup artist, no stylist, no lighting, and no Photoshop!
I collected their stories, too. Some of them have alopecia, some have been through chemotherapy, and others simply like being bald. When I showed the pictures to my clients, every single magazine that saw the story (about 20) refused to publish it for the very same reason: those pictures might clash with the feminine ideal supported by advertisers. Mainstream magazines have a preference for the Barbie-fication of women. As one of the editors told me, "If we publish that it's cool being bald, shampoo firms will get mad at us!"

29. The Delivery

Certain photographers simply send everything to the magazine. If I have time, I try to visit in person and show the pictures on my laptop while I tell a bit about the reportage. My enthusiasm is part of the package. The little episodes that I tell to the editor off the record help ensure my work is aptly interpreted. This is also the moment to propose new ideas; if what you are delivering is considered good, you will have more chances. Anyway, once your work is in their hands, they are in charge. This means that your ingredients might be paged up to create a great article . . . or not! Be ready to feel very frustrated: it can happen that they give a certain twist to your story that was not at all your intention. Magazines are products, and you are just a tiny part of the production machinery, especially if you are a beginner. Little by little you might develop a trustful relationship with your clients and they might give you a little more consideration. If you want to avoid unpleasant episodes, be as professional as you can and deliver something that already has a powerful structure. Still, you will have no guarantees about the result. By the way, you know that when you walk into an editorial office you need to be prepared to swim with sharks, don't you?

▼ Jeweler and anthropologist Pippa Small photographed in her Notting Hill Gate shop, in London. When she shows her jewelry, she also explains the story and the meaning of every bead or shape. Her presentation adds value to her creations. Pippa also makes very clear that "this place is an excuse to awaken my clients' opinion to what is really important to me: tribal people's rights." Part of the shop's income is used to support initiatives to empower ethnic minorities and organize them to defend against exploitation by big multinationals.

30. Publishing on the Internet

These days, there are many photographers with excellent reportage ready to be published, and they barely manage to get an appointment with an editor who, in all probability, will reject their work. Of course, there are also tons of photographers with mediocre pictures that are dying to see them published. Paper magazines do pay photographers (well, sometimes they don't). A very few online magazines pay a small fee to their contributors, but the vast majority offers only exposure. If you are a pro, you know that exposure won't pay your bills, but this is the way the Internet works: text and pictures are offered for free to the public. So, how can a photographer fund his or her work and stay in business?

This is the question that a few thousand photographers are asking themselves nowadays. The rules are changing, and no one has a good answer.

In any case, online magazines can be very picky, and if you want to publish with them you have to follow their submission guidelines and put yourself in line. Some of them even ask a submission fee. I recently read this ad: "New Photography Magazine— Photographers Needed. We will not be charging for the photographers to be in it." Ouch! We used to get paid for our pictures! Anyway, the Net is a great self-promotion tool. It helps you to reach a huge audience and get your work known. Be mindful to use it and not to be used by it.

▼ Acrobats on the beach, Ipanema, Posto 9.

31. Selling Your Pictures

So you want to sell your pictures, but you are not sure about what is the best way to do it. Until not so long ago, there were not many ways to market your work. Nowadays, things are different, and you can be creative even about the procedure you choose to reach your clients and get paid. I have experimented with all the listed examples, but they are not the only ones. For instance, I have never tried crowdfunding. Just thinking about starting a crowdfunding campaign to finance a shooting trip makes me feel uncomfortable because there is a lot of work involved. But some photographers have done it. Also, I never shot a sponsored feature with the aim of shooting something else too, but I know it's possible. Tourist offices or humanitarian organizations are happy to pay for a good set of images. In that case, you must follow their instructions and show exactly what they want you to show in your pictures. While shooting for them, you could also shoot a feature that interests you. You would then have a version for them and a version to distribute on your own. But they might not like it, especially if what you reveal in your feature is different from what they have asked you to cover. Anyhow, there are several ways you can market yourself. Try some of them out, experiment, see what works best for you, and keep trying out new ways to sell your work.

Build Your Own Pool of Clients

In the early 1990s, I started writing articles for fashion magazines, which occasionally also included my photos. But I didn't think it could be serious work. Later on, I put together a few pictures (and a lot of ideas!) and I went to meetings with editors.

I enthusiastically told them what sorts of photos I'd like to take, the stories I had in mind, and the people I would be able to portray. I believe I owe my success as a photographer to my ingenuousness. I was so unrefined and off the wall that I caught everyone a bit off guard. The magazine editors I met were probably thinking: "This guy is a bit nutty, he takes some strange photos, let's see what he can do." And so they gave me my first jobs.

They liked my work, liked it a lot, and in very little time I had a large number of clients and I began to travel around the world.

If I were starting now, things would be harder. Still, this is the way to build one's own pool of clients.

Where to start? First, you need to have something unique to offer. Second, you better have a quick and impactful way to get your message through. Editors and photo editors are busy people, and they don't like to make any effort trying to spot some hidden potential in you. Getting an appointment with the right person can be

impossibly difficult, so make sure to introduce yourself in an appropriate way. These are the steps to follow:

- Find out what magazines you would like to work for and look for the photo editor's email. Editor contacts are often published in the magazine. If they are not, call the magazine office and ask for the contact you need.
- Send a *short* email that includes a teaser of what you want to propose and a link to your website. Remember, nowadays assignments are rare, and you will have more chances if you have something ready. If they like it, it might lead to something more.
- Wait a day or two. If you get an answer, perfect. If you don't, try to call the photo editor and ask if he/she got your email. Try to get an appointment.
- If you manage to get an appointment, go there *ready*. Bring your images well organized. You might start showing an essay and see that it is not generating much interest. Be sure that you have something else handy. If you want to talk about a project you haven't developed yet, make sure to have at least one image that suggests its mood. It might happen that you show them something that they are looking for. In that case, be ready to negotiate a price. Ask how much they normally pay and see if you are happy with that price. Don't give your pictures away for free or they will always expect the same from you! Certain wanna-get-published photographers, in their attempt to break in,

don't care about getting compensation for their work. You don't want to be one of them.

If you walk away from your appointment simply knowing that they want more details about a certain proposal, it's already a good result. Send them what they need. Be reliable, precise, professional. Meet deadlines. They will appreciate it. By the way, your work has to be good, too.

Have an Agent (or Two, or Three, or More)

There are two main kinds of photography agents: the ones that deal mainly with fashion and advertisement and the ones that deal mainly with photojournalism. In both cases, it's not easy to be represented by an agent; there are many, many photographers who are knocking on their doors every day.

Photojournalism agents usually distribute features to clients in a certain geographical area (e.g., France or the USA) and have a network of sister agencies in other parts of the world. When they sell a feature they keep a commission ranging from 40 to 60 percent. When a sister agency sells your feature in another country, they negotiate the price and keep a commission, too. Duplicate commissions will kill your earnings. Once the Japanese sister agency of my French agent sold one of my features. I was paid peanuts. Other times, it went much better. In any case, you can ask your agent not to give your features to sister agencies and, instead, you can work with several agents yourself—of course, only if you can find several agents who are willing to represent you!

For a period of time I was represented by 5 different agents in 5 different countries. It wasn't easy to get those contracts. Having an agent is not a guarantee of selling your work. If an agent is good and believes in what you do, he or she will promote you actively, try to sell the features that you have already produced, and possibly find assignments. Far too often, agencies simply add a photographer's archive to their website and wait for someone to ask for those images. Nowadays, big agents sign contracts with publishing companies that guarantee they will buy a large amount of pictures per year for a pretty low price. That's why they need a lot of images. Being represented by an agent can be a good thing if they find you clients and work, but it can also be not so good if they simply distribute for a low price what you produce with your money.

Imagebrief

Imagebrief (www.imagebrief.com) connects clients with photographers. It's not about news; rather, it's about travel, stock, and commercial images. Clients are mainly publishers and advertising agencies. They post a brief for the image they are looking for along with their budget and intended usage. Pricing and licensing terms are specified upfront. If photographers have pictures that match the request, they can submit them to the brief and wait to be chosen (or not). All images are subject to approval before they are displayed (and they can be picky).

When an image-buyer selects the needed image and buys it, the photographer receives up to 70 percent of the license value.

Briefs can be very specific: say, a black rhinoceros in Namibia (preferably with a baby rhino), Chinese colored lanterns at a Sydney food festival, or a person troubled by air pollution blocking his/her nose and mouth (air should be smoky, gray, disgusting).

Photographers receive daily emails with briefs and usually have a couple of days or a few hours to submit their images. I joined Imagebrief at the beginning of their adventure. They are growing fast, their interface is getting more sophisticated, and the number of briefs multiplies. Some briefs are paid very well, others not so well. I wouldn't count on them to pay my bills, but sometimes a client is looking precisely for a picture of that place or that person and— hey!—I have one! There are various levels of engagement; I could probably get more from the site by setting up a nice profile with galleries and so on. So far, I just use it in a basic way, submitting only the very few specific images that I happen to have. I am happy about a sporadic opportunity knocking at my door. If you have a very large archive, you may really benefit from this site.

Diimex

This is a funny story. A while ago, a popular Australian TV show mentioned me and my work without me being aware of it. The next day, I noticed thousands of visits from Australia on my website. I couldn't understand why. I also got a few emails, one of them was from Diimex (www.diimex.com), proposing that I join them. At the time they were in beta and not officially opened yet. At first, I wasn't sure about getting into one

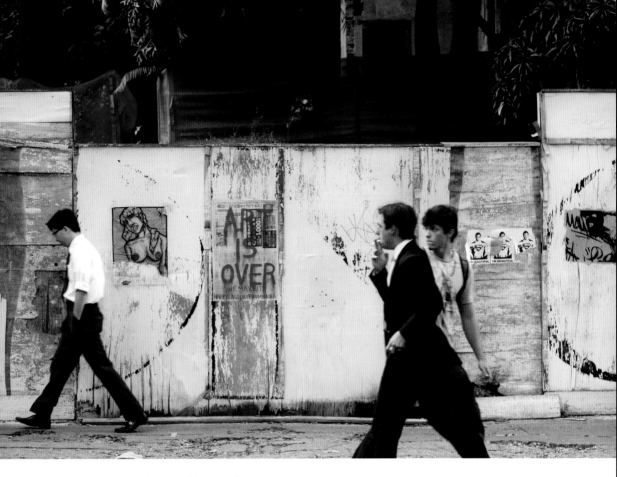

▲ São Paulo, in the Jardins neighborhood.

more Internet adventure, but their innovative business model attracted me.

Diimex is an online marketplace that sells to clients all over the world. Photographers upload their features to the site, and only registered clients can see them—not the occasional visitors (there are no occasional visitors) and not even other photographers (who might want to copy your idea). Exclusive features are then put on auction among potential clients and the one (or ones) who offers the highest bid gets your feature. If what you shot is *very* interesting, you might have one auction winner for several countries. Once the content has been published, it's placed in the premium section of the site to be re-sold, and after a while it goes into the stock library. Photographers receive up to 75 percent of the sale, and payments are fast. At Diimex, they prefer quality over quantity; they want to keep the prices not too low because they want photographers to be able to produce quality content. They are selective with photographers and selective with what you can upload (their philosophy: less is more). They stress the importance of choosing captions and keywords, and you must follow their guidelines! As a result, they are building a well-organized platform with a lot of potential both for

editorial and commercial content. From this sophisticated machine you would expect spectacular sales, but this hasn't been my experience so far. Still, I am very happy about our cooperation. The site is constantly improving, and they are introducing new ways to market photographers. Diimex is doing a great job with photojournalism and photography in general. They don't perform miracles (yet), but that seems to be their aim.

Photoshelter

Photoshelter (www.photoshelter.com) is a huge online image bank where both professional photographers and amateurs can buy space and upload their images. Each photographer can build a site divided into galleries, with each gallery dedicated to a feature. I found it extremely useful in order to

show new clients how I work. With a simple link, I could share a certain feature and they could go through all the images.

Clients can find pictures with keywords. Let's say that a magazine is looking for a series of images on a certain topic. They will search by that keyword and find the corresponding images that have been uploaded to the site. Right now the site numbers about 200,000,000 images and 80,000 photographers. There are good images and terrible images, too. If you have all your pictures well organized and they have the right keywords, there is a good chance they will be found by clients whose existence you never suspected. The site has several functions and can be personalized in many ways. If you decide so, clients can also buy your images directly from the site and pay on the basis of a customizable price list.

▼ **Sandy Bay, just out of Cape Town.**

▲ (left) Fog in Wales. ▲ (right) Central Park, New York.

For a number of years, I put a big part of my archive on Photoshelter, and it was a good choice. The downside of the site is that, if you don't have a lot of images that are selling, you end up paying every month for having your archive online without recouping the investment. And there is another problem: the site is browsed not only by clients willing to buy features but also by bloggers willing to steal your pictures. Of course, this doesn't only happen on Photoshelter.

Protect Your Pictures

If you publish your pictures online, sooner or later someone will download and use them without your consent—maybe with the credit "Photo: Internet." A quick way to find out where your stolen pictures are is Google Images. Alternatively, you could use the site tineye.com. Once you find your images published, evaluate if taking action is worth your time. A teenager blog is not the same as a popular travel site. If you decide to procede, write to the webhosting company and let them know that one of the sites hosted by them is infringing your copyright. According to the Digital Millennium Copyright Act, they must take down the infringing material. If you are not sure about who

is hosting that site, you can search it on internic.com/whois.html. You can also go on the dmca.com site and fill out a form to have your content removed. While you are there, check out their solutions to protect your pictures.

Having your pictures deleted is one thing, but how about asking for compensation? You can do it yourself or, better still, ask an attorney to do it for you. One option is to contact photoattorney.com and find out if they can help you and how much it would cost. Or you can skip all of the above and go for the total package. When you upload your images on imagerights.com, they will alert you each time they identify uses of your work, and they will take on a case if needed. If you opt for a free plan, you will have to pay $50 for each case and you will get 50 percent of net recovery. Photoclaim.com will also find illegal usage of your images and ask for compensation. If the opposing party is not willing to pay, they will file a lawsuit covering all incurring costs (free for you) and you will receive 65 percent of the paid damages. Online copyright infringement is now raging out of control, and we can expect more companies offering services to protect photographers from online picture thieves.

32. Videos

So you have a DSLR camera that shoots video and you want to give it a try. If you are an expert photographer, you are certainly at an advantage, and there is a good chance that your videos will be good. But videos are not pictures, and so there are a number of things that you need to keep in mind when shooting them. For instance, since you are used to shooting horizontal and vertical images, it's very likely that you will feel like doing the same in video, forgetting that monitors are *horizontal only!* It seems like a trivial detail, but it's not, and you might be surprised at how many times—at the beginning—you'll automatically feel like turning your camera vertical.

The white balance is another aspect that is sometimes ignored by photographers, but it's essential when you shoot videos because it will guarantee continuity and uniformity among the various scenes. Adjusting the white balance will not only help you get the most accurate colors possible but will prevent having one scene with a bluish tint (as usually happens with fluorescent lighting) or a warmer yellowish tint (incandescent lighting). Different sources of light have different color temperatures. Most cameras have an automatic color temperature adjustment mode. Sometimes they work fine, but you'll feel safer if you do it manually. You will need a white card or an 18 percent

gray card specifically designed for the purpose. Different cameras have different ways to white balance, so you'll need to check the user's manual. White balance needs to be adjusted each time the light conditions change. Another setting that you will have to decide is the format. Again, different cameras offer different options. If you select 1080p (it means that your frame will be 1920x1080 pixels) you'll get a pretty good quality. If you already know that your video is going to be used on the Internet only, you can select 720p (1280x720 pixels).

Another important difference to remember is that when you are shooting a picture you set the focus where you want it, and that's it. With video, things are different because your subjects will move and it's easy to lose the focus on them. The camera's focus gear is not very practical when it comes to adjusting the focus while filming. That's why one of the most popular accessories for videomakers is a "follow focus," an external gear that allows the photographer/operator to change the focus with fluid and smooth precision.

Covering certain news events, you might not have time to adjust the focus. In that case, I suggest using a wide-angle lens that will give you greater depth of field. If you need to move the camera a lot, the result will probably look dynamic, and that's

fine—but be careful because the image might also look shaky. In order to avoid that, in emergency situations, you could rest your camera on a table, a small wall, a staircase, or any other available stationary surface. Of course, your capacity to point the camera at what you want will be extremely limited. There is a better way. A camera shoulder brace, or shoulder tripod, will allow you to shoot your videos while stabilizing most of the shaking and trembling so that you can follow your subject and move or walk with ease. There are several brands that offer different versions of this important accessory. I suggest you browse through what's available and make a decision only after checking out multiple solutions. A popular brand is SunSmart, whose handheld camera stabilizer balances steadily on your shoulders and includes a follow focus and even a matte box, a device mounted at the end of the lens that blocks the sun and pre-

vents glare and lens flare. If you are wearing a camera shoulder brace, you can also dare to use long lenses. I advise against using them when the camera is handheld because, even using stabilized lenses, the vibrations would be too visible. In any case, if you are planning to shoot videos with your camera, you must have lenses that are very well stabilized.

If the situation allows it, the use of a tripod will give you images that are steady and easier to look at. Of course, when you are shooting reportage, you will often find yourself in places where you need to be fast and dynamic, and a tripod is the last thing you want to use. Anyway, if you do have the opportunity to use a tripod, remember to get a tripod head that is suitable for shooting videos. Choose a head with soft, smooth movements so that you can turn and orient your camera with a fluid motion. A tripod can also be useful if you decide you don't

▼ Rio de Janeiro, Ipanema, beach.

need camera movements at all (stationary camera), as may be the case in interviews. Sometimes a monopod will do.

Another interesting accessory to keep in mind is a camera slider, a sort of rail that you can slide your camera along to get those panoramic camera movements. Again, you can get several different kinds of sliders. Most of them are lightweight and collapsible. You can be creative with a slider. For instance, you can use it horizontally and film a scene from left to right (or vice-versa) or you can position the camera on one end of the slide and the subject at the other. This solution is particularly indicated for small objects because by getting closer to them you'll show an increasingly smaller and more detailed portion of their surfaces. Of course, remember to focus!

Especially if you are shooting outdoors, you might want to consider getting a magnifier viewfinder that will enable you to have much better control of what you are shooting. Prices range from $70 to $500 or so.

The big success of DSRLs for video work also derives from the fact that the device is not too expensive and you can change lenses. Until not so long ago, only the most sophisticated and pricey cameras had the option of changing lenses, so be creative!

However, being creative doesn't mean using all the possible camera movements and constantly changing perspective. That's confusing. Simplicity is often a better option. For instance, if you decide to shoot a panoramic view moving your camera from one point to another, you'll get a better result if you have a clear and well-composed

▼ (top left and right) Slider and slider on a tripod.
▼ (bottom left and right) Shoulder brace in use and folded.

image to start from and an equally clear and well-composed image to arrive at. The camera movement has to be fluid, and you want to start shooting a few seconds before the camera starts moving and stop a few seconds after the camera stops. Those extra frames will come to your aid during the editing. For the same reason, when you are interviewing someone, you want to start shooting a few seconds in advance and stop your camera a few seconds after your interviewee has stopped talking. Remember to ask him/her not to look away immediately.

What you shoot will need to be edited, and the best thing for describing a given situation is having shots that have been captured from many different angles: full field, middle ground, close-ups, and details. A variety of points of view will help you develop an interesting sequence that does a good job of illustrating what's going on when you edit the images.

In order to have an interesting and dynamic final video with good rhythm, it would also be good to have images where the camera is moving and images shot with a stationary camera—but this is not something that you improvise. You need to decide what style you want to use well before you start shooting. What kind of atmosphere? What kind of rhythm? In other words: what kind of language? Especially for those of you who are embarking on their very first experiences, it does help to find a video you like and analyze it scene by scene. By doing that, it is possible to find out how a certain mood has been achieved—the framing, camera movements, rhythm. Was

the camera handheld or, more likely, on a tripod? Is the editing fast? Are there many details? Was it shot with a wide angle, a 50mm, or a variety of lenses? A video shot entirely on a tripod and edited at a slow pace will have a totally different impact from a video shot with a handheld camera and edited dynamically.

It might be useful to pay a visit to https://vimeo.com/categories and check out different videos for inspiration. In any case, the most important things to decide in advance are lenses, vantage points, camera movements, and timing. Those elements will give a specific connotation to your video.

Besides these fundamental factors to keep in mind, the main part of your job concerns the angle you are giving to the story you are reporting. As you know, the same subject can be narrated in very many ways. Who are you interviewing? What kinds of questions are you asking? Are you giving space to someone with a certain opinion and also to someone else with a different opinion, or not? The video allows you to put together a compelling visual narrative that includes sounds, voices, and movements. Playing a bit during the editing, you'll be able to use not only videos, but also pictures. A simple cross dissolve (one image fades away while another comes to life) can be very powerful with the right sequence of images. And you could also zoom in, zoom out, make an image glide from left to right or in any possible direction. If this option sounds good to you, make sure to record sounds to use in postproduction. Say you are shooting in

a market and you put together a sequence of images that show both people and the setting. A background of voices and noises of the market will help to give context to the story. If you are interviewing someone, it can be quite impactful to use the voice as a soundtrack to the flow of images. This is not just a postproduction trick, this is a language, and in order to master it you need to accumulate some experience with it. Another interesting way to use your photography and video-editing skills is time-lapse photography, which speeds up the progress of slowly unfolding events. For instance, you could show a flower blooming, a fruit decomposing, a panoramic view from sunrise to sunset, or several hours of traffic at a crossroad squeezed into one minute or less. You can certainly use the technique from time to time in photojournalism projects, but it can't be the main language. For shooting a time-lapse sequence, you need to place your camera on a tripod and set an intervallometer, a device that will tell your camera to snap a picture at specific intervals. A similar technique is called stop-motion; you photograph an object in a certain position, then you move the object and snap another picture, than again and again. The final result is an object moving—for instance, a book opening and turning pages. Unless you want to use this effect for titles or such, I'd say that it's not really useful for photojournalism videos. But you never know.

A video camera shoots 30 frames per second (NTSC) or 25 fps (PAL). Shooting at a faster frame rate (50 or 60 fps) creates a slow-motion effect that allows viewers to see details normally not visible because the action is too fast. If you really like the slow-motion effect and you wonder how it would be to shoot at an even higher rate, you might try one of the plug-ins that let you slow down (or speed up) your scenes in postproduction. A popular one is Twixtor.

Once you have shot all your scenes, you need to start the postproduction phase. You will have to import all your footage, pictures, sounds, music, and sound effects into an editing program. A popular one is Adobe Premiere, which works on both PC and Mac and with all video formats. For adding headings, graphics, and such use Adobe After Effects, one of the best video special effects programs. It's particularly practical because it's compatible with all the programs in the Adobe Creative Suite. Another excellent program is Final Cut, for Mac users only. The special effect program coupled with Final Cut is called Motion. As for what happens with Canon and Nikon, Final Cut and Premiere also have their fans who are very loyal to one program or the other. It's up to you find out what works best for you.

All in all, shooting videos is not an easy task. You need to feel comfortable with new technical challenges, visual sequencing, focus issues, audio levels, and a lot more. I have given you an overview here. Should you be curious to find out more detailed information on very specific topics, you can turn to a tutorial section on Vimeo that you will find is well worth a visit—https://vimeo.com/search?q=dslr.

▶ Indian flower lei.

33. Now It's Your Turn

In this book, I have shared with you what I consider important. Remember, this is my point of view. There are other ways to do reportage. I know a photographer whose approach is very different from mine. He moves, let's say, to India for 6 months, buys a bike, and goes around with no plans, waiting to bump into something inspiring to photograph. He snaps the shutter guided by chance, and his photos are beautiful. I am more organized, and this works for me. Are you ready to find out what works for you?

I hope that this book gave you some good inspiration to support your career. If you want to dig into the matter some more,

consider joining me at one of my workshops. You will find information on workshop-ritratto.it. Remember: reportage photography not only allows you to express and share your unique vision of the world, it's also a great tool to explore yourself. Each time you point your camera, you have the opportunity to become more conscious of what attracts you and what makes you feel uncomfortable, of what you want to see and what you don't want to see. It's a challenge and a great opportunity.

Now, enjoy your next reportage!

If you enjoyed reading my book, please recommend it to a friend.

▼ Big Island, Hawaii. ▶ Woman feeding pigeons, Jardin Des Tuileries, Paris.

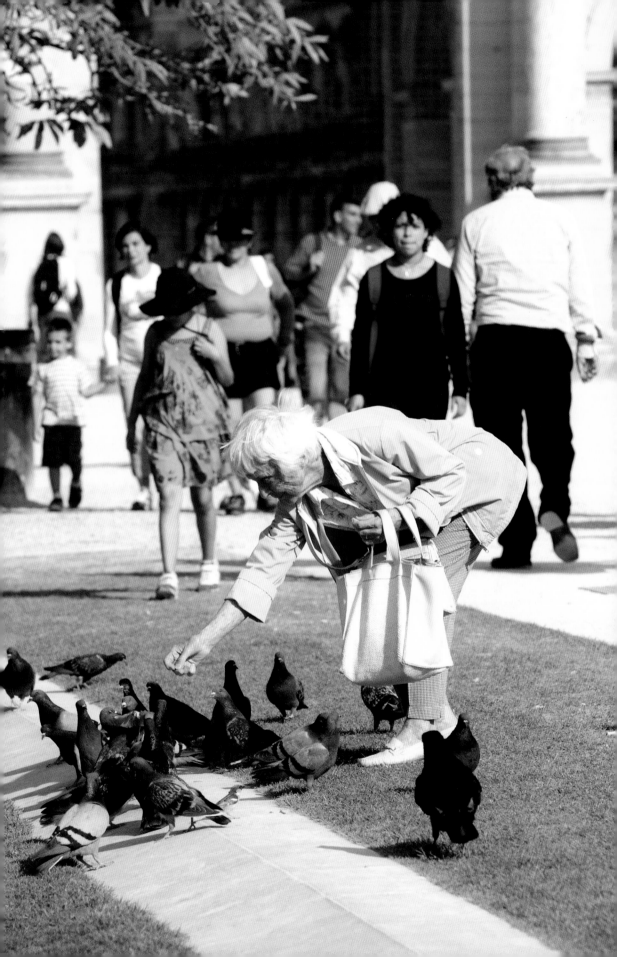

Index